NEVILLE JACOBS

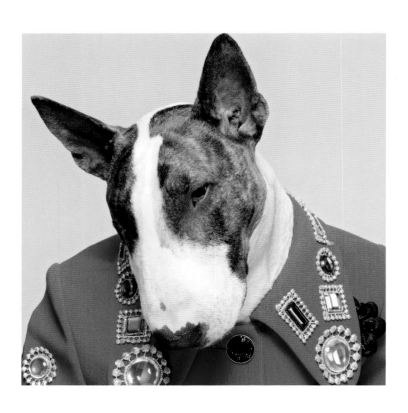

NEVILLE JACOBS
I'M MARC'S DOG

NICOLAS NEWBOLD AND MARC JACOBS

RIZZOLI
NEW YORK

New York · Paris · London · Milan

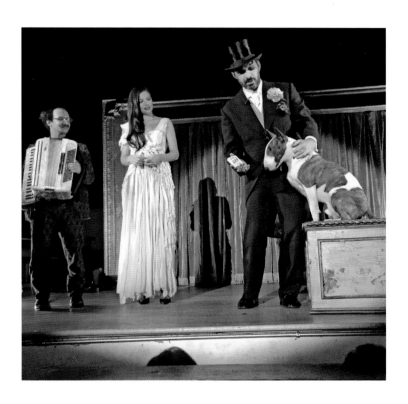

A FULL-HEARTED THANK YOU WITH OVERWHELMING GRATITUDE TO NICK NEWBOLD, WHO NOT ONLY CONVINCED ME THAT I WAS READY TO WELCOME A NEW BULL TERRIER PUP INTO MY LIFE, BUT WHO ALSO CONTINUOUSLY DELIVERS ON HIS PROMISE TO CARE FOR AND LOVE OUR EXTRAORDINARY NEVILLE.

AND A THANK-YOU NOTE AND LOVE LETTER TO MY BEAUTIFUL NEVILLE, WHO WITH EVERY GLANCE FROM THOSE EXPRESSIVE LITTLE TRIANGULAR EYES, EVERY HUMANLIKE CUDDLY EMBRACE, EVERY SPONTANEOUS OUTBURST OF CLOWNISH SILLINESS THAT MAKES ME SMILE AND LAUGH, CALMS ME LIKE NOTHING OR NO ONE EVER HAS—AND WHO FILLS MY HEART WITH THE GREATEST HAPPINESS AND JOY, FOREVER REMINDING ME THAT PURE GOODNESS AND TRUE LOVE REALLY EXIST.

MARC JACOBS

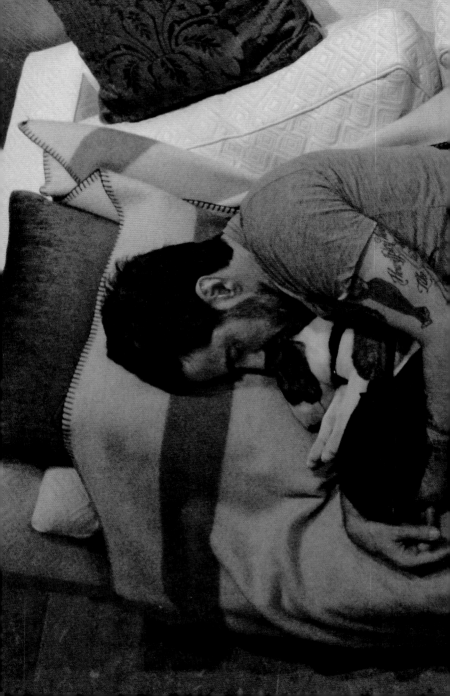

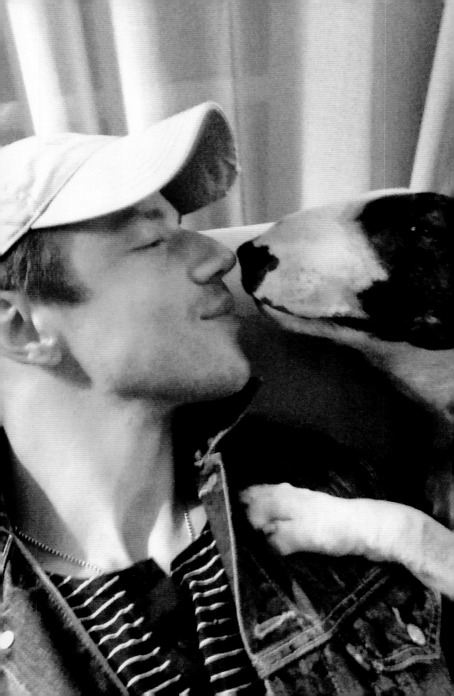

BY PURE FATE OR INEXPLICABLE COINCIDENCE, NEVILLE WAS BORN ON THE EXACT DAY I BEGAN WORKING WITH MARC. I'M QUITE CERTAIN NEITHER ONE OF US COULD HAVE ANTICIPATED THE BOND THAT WOULD FORM AS A RESULT OF OUR SHARED ADORATION FOR THE WILD LITTLE DINOSAUR THAT CATAPULTED INTO OUR LIVES—AND SUBSEQUENTLY THE LIVES OF ALL THOSE IN THE OFFICES OF MARC JACOBS INTERNATIONAL.

NEVILLE LIVES HIS LIFE IN PAUSE (QUITE LITERALLY). I OFTEN THINK HIS PURPOSE, IF YOU BELIEVE IN THAT SORT OF THING, IS TO TEACH PATIENCE, TOLERANCE, AND LOVE. HE HASN'T CHANGED MUCH SINCE HE WAS A PUPPY, AND WHILE I'VE COME TO LEARN (THANK YOU, SOCIAL MEDIA) THAT HE IS JUST LIKE OTHER BULL TERRIERS IN THE SENSE THAT THEY ARE "ALL THE SAME," HE IS NOTHING LIKE A DOG WHATSOEVER. THERE IS A DIFFERENT KIND OF DRUMMER BEHIND NEVILLE'S EYES, ONE THAT KEEPS AN ODD AND GENTLE RHYTHM.

YES, HE'S A DOG, BUT A DOG WITH A CONSIDERATION OF THINGS. WHAT HE HAS GROWN INTO IS AN EXTRAORDINARILY WELL-BEHAVED AND WELL-MANNERED BEING, IN LARGE PART DUE TO THE LESSONS BESTOWED UPON HIM BY HIS "DEN MOTHER" AND TRAINER STACY ALLDREDGE AND HER TEAM. A KIND OF VILLAGE RAISED NEVILLE, AND IF YOU KNOW ANYTHING ABOUT A BULL TERRIER, YOU KNOW THE MORE THE MERRIER! BUT EVEN WITH ALL THE OBEDIENCE, COGNITIVE, AND "ETIQUETTE" TRAINING, NEVILLE HAS ALWAYS PREFERRED SITTING TO WALKING, SNUGGLING OVER PLAYING, AND EATING ABOVE ANYTHING ELSE. AFTER ALL, HE'S JUST A DOG…

NEVILLE'S JOURNEY FROM THE MIDWEST TO NEW YORK CITY WAS SOMEWHAT LIKE A FAIRYTALE, I SUPPOSE (AT LEAST IN HINDSIGHT), AND CAPTURING IT IN ITS (MOSTLY) CANDID MOMENTS ALONG THE WAY REMAINS AN OFTEN HUMOROUS VISUAL ACCOUNT OF TIME AS IT PASSES—HIS, MINE, AND MARC'S. HIS RISE TO STARDOM, MEANWHILE, BEGAN AFTER FREQUENT APPEARANCES WITH A BEVY OF WILDLY POPULAR MODELS ON THEIR VARIOUS INSTAGRAM ACCOUNTS—THANKS TO THE STYLIST AND LONGTIME FRIEND OF NEVILLE'S, KATIE GRAND. AND THUS BEGAN A DIFFERENT KIND OF JOURNEY FOR THE PUP, WHO JUST SO HAPPENS TO CALL MARC JACOBS HIS DAD.

PERHAPS THE MOST UNEXPECTED PART OF THIS FUNNY LITTLE JOURNEY THROUGH THE PERSONIFICATION OF NEVILLE IS THE REAL SENSE OF AUTONOMY IT HAS CREATED. THE AMOUNT OF PRESS NEVILLE HAS RECEIVED AND CONTINUES TO RECEIVE WILL NEVER CEASE TO AMAZE ME—FROM HIS APPEARANCES IN FASHION MAGAZINES AND NEWSPAPERS TO A BOOKMARC ADVERTISING CAMPAIGN THAT LANDED HIM A BILLBOARD IN LOS ANGELES (TWICE!). YET, HIS FAVORITE ACTIVITIES WILL FOREVER BE PICKING THROUGH GARBAGE CANS AT WORK AND, OF COURSE, OBLIGING SELFIE REQUESTS FROM PERFECT STRANGERS ON THE STREETS OF NEW YORK.

MOST DAYS, IT'S AS IF NEVILLE IS JUST ANOTHER EMPLOYEE AT MARC JACOBS, GOING ABOUT HIS DAILY LIFE WITH HIS BEST FRIEND AND COLLEAGUE, CHOO CHOO CHARLIE, THE FRENCH BULLDOG. WHILE CHARLIE IS TECHNICALLY A NEWBOLD, FOR ALL INTENTS AND PURPOSES HE AND NEVILLE ARE BROTHERS. SINCE I BROUGHT CHARLIE INTO MY LIFE, ABOUT A YEAR AFTER MARC GOT NEVILLE, THESE TWO DOGS HAVE BEEN VIRTUALLY INSEPARABLE. THEIR RELATIONSHIP IS UNLIKE ANY OTHER I HAVE EVER EXPERIENCED OR OBSERVED—THEY SIMPLY HAVE A PURE LOVE AND MUTUAL RESPECT FOR ONE ANOTHER.

THEIR PARTNERSHIP AS COLLEAGUES, BEST FRIENDS, AND STORY-TELLERS IS ALL TOO GENUINE. FROM THEIR DAILY ADVENTURES GETTING TO WORK (YES, THEY'RE BOTH AT THE OFFICE ALMOST EVERY DAY!), THEIR FREQUENT TRIPS OUTSIDE THE CITY TO THE BEACH OR THE COUNTRY, AND THEIR ANNUAL WINTER HOLIDAY RETREAT TO SUNNY ST. BARTH'S, TOGETHER NEVILLE AND CHARLIE HAVE NOT ONLY LEARNED THE VALUE OF AN HONEST DAY'S WORK BUT ALSO THE GOOD FORTUNE OF UNDERSTANDING HOW THEIR HARD WORK CAN ALSO BE REWARDING.

THE TRUTH IS, NEVILLE NARRATES HIS OWN STORY; I JUST HAPPEN TO BE AROUND WHEN HE'S TELLING IT.

NICOLAS NEWBOLD

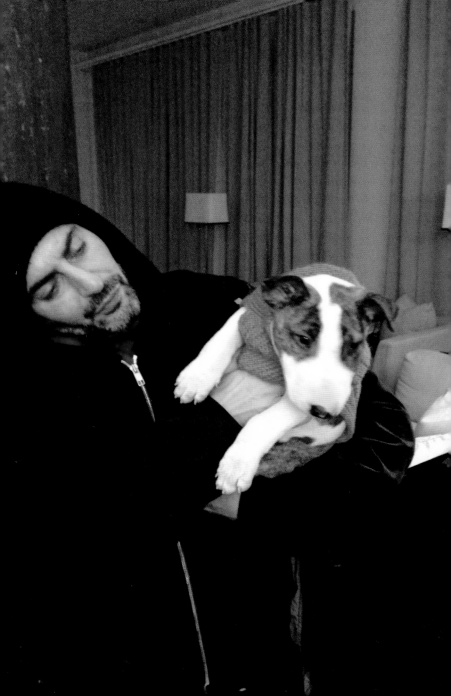

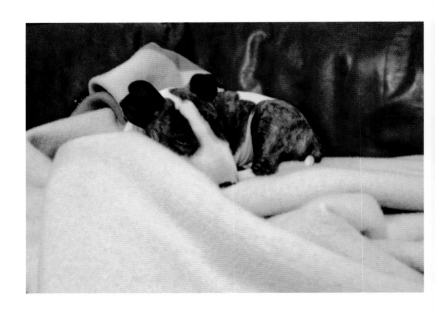

WHEN I WAS 9 WEEKS OLD
AND 14 POUNDS OF STUBBORN.

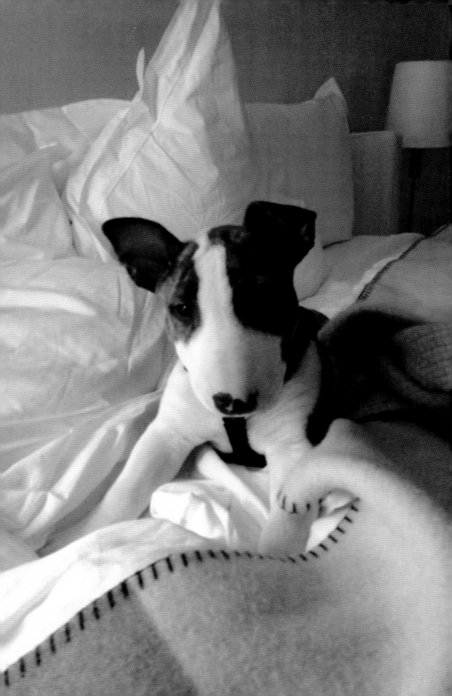

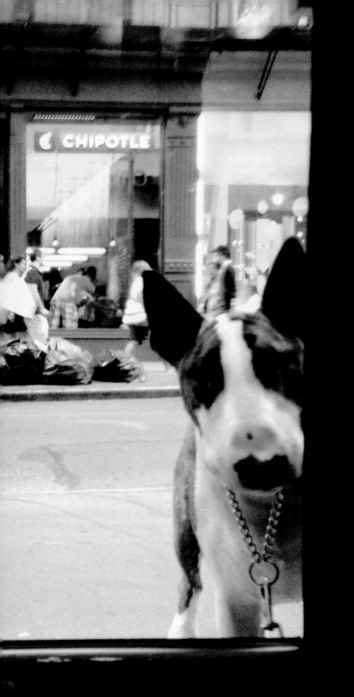

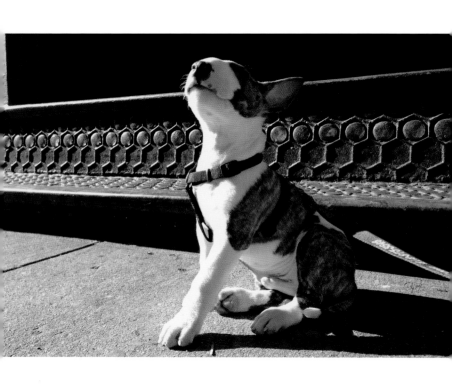

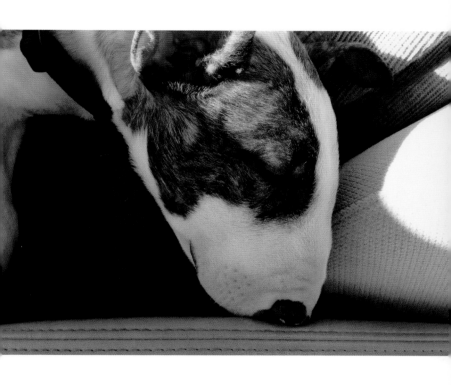

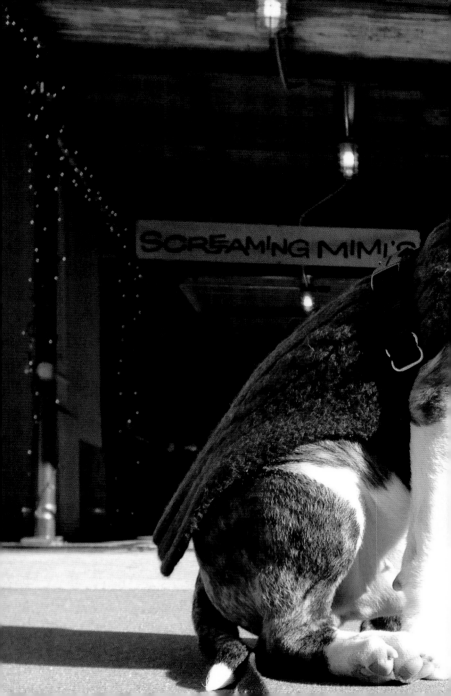

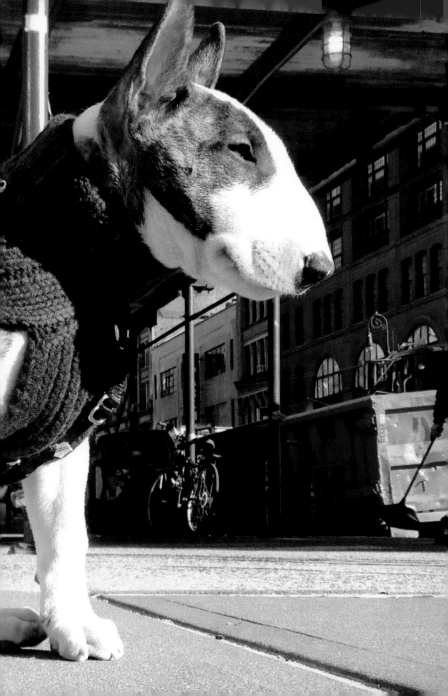

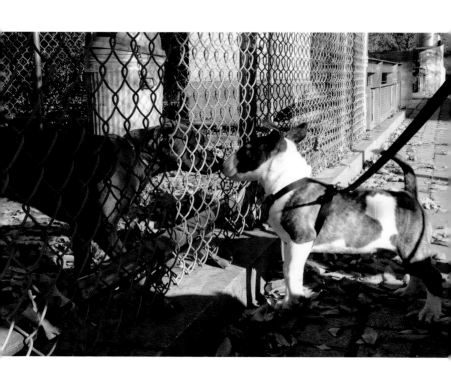

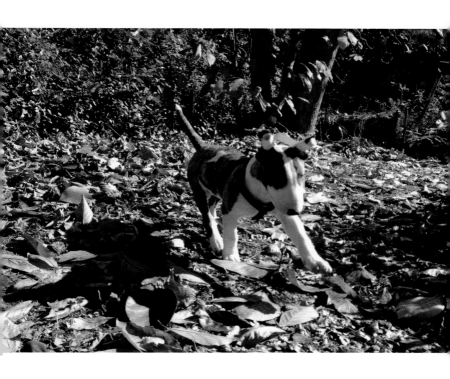

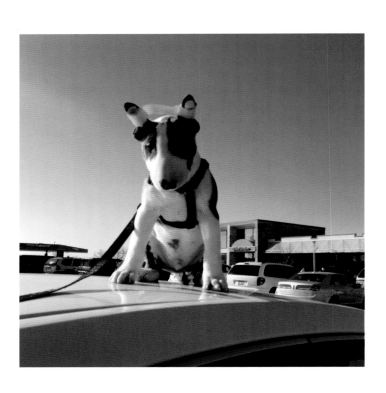

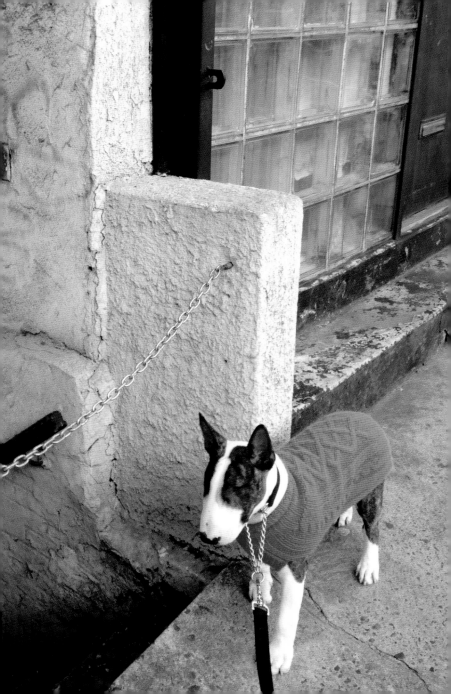

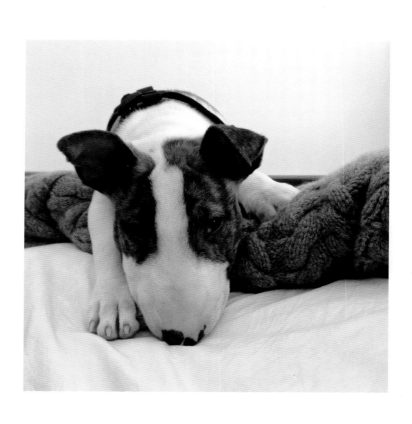

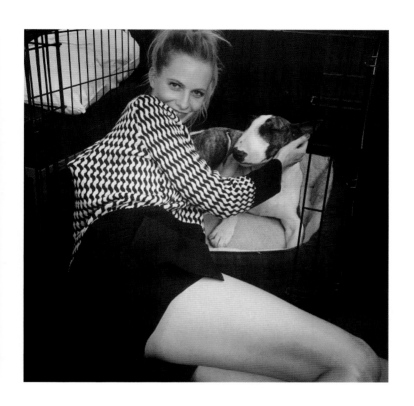

BEING CAGEY WAY BACK WHEN
WITH THE BEAUTIFUL POPPY DELEVINGNE.

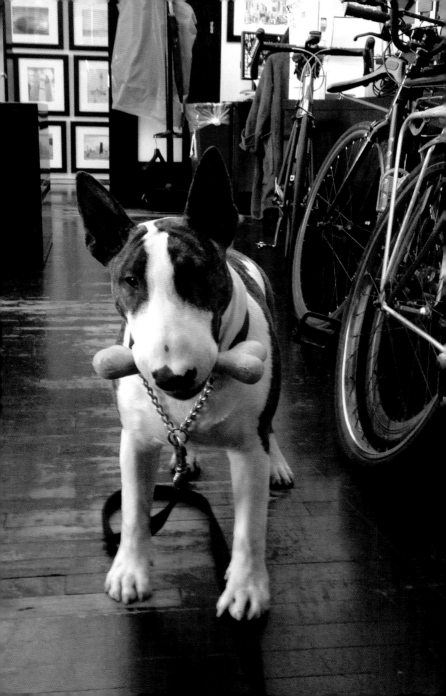

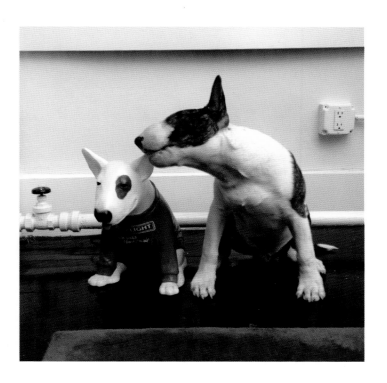

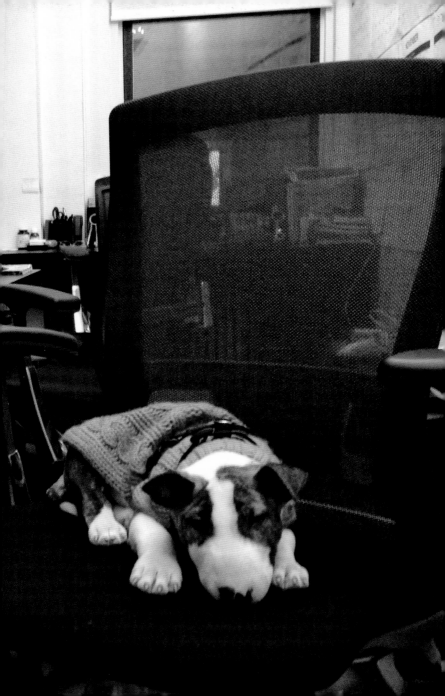

I'VE ALWAYS BEEN MORE INTERESTED IN
DECONSTRUCTION THAN DESIGN.

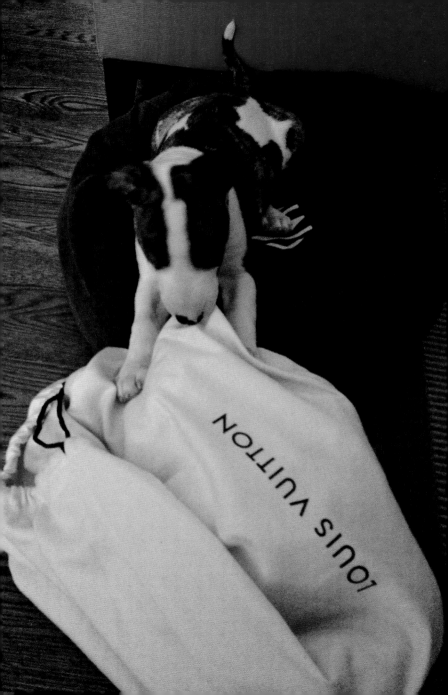

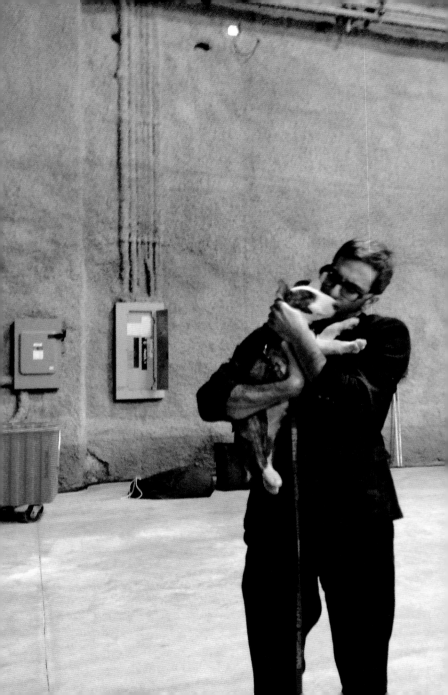

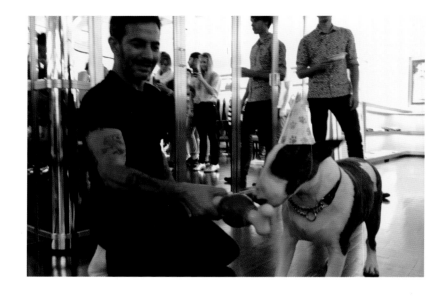

MY COLLEAGUES GOT THEMSELVES A CAKE
IN THE SHAPE OF MY HEAD FOR MY FIRST BIRTHDAY,

AND ALL I GOT WAS THIS LOUSY HAT.

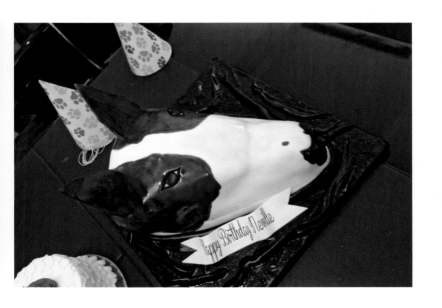

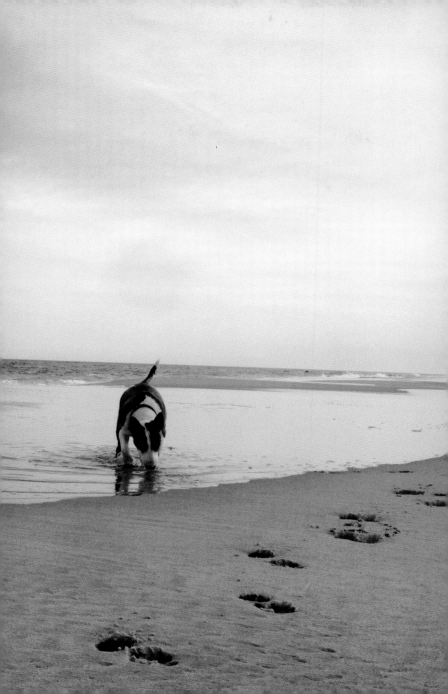

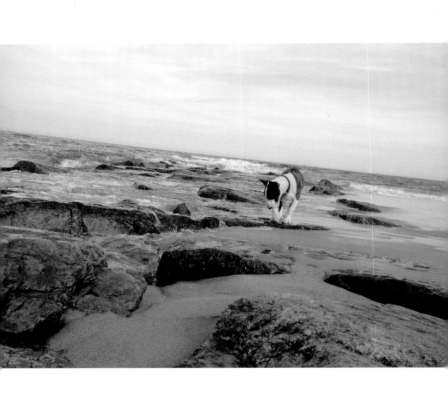

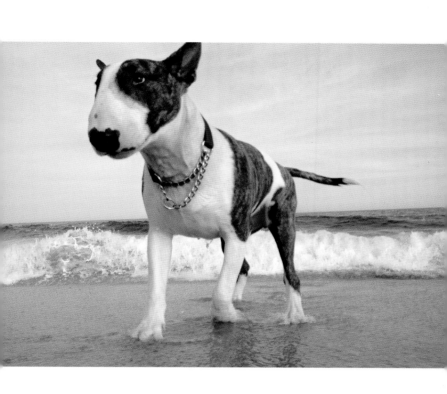

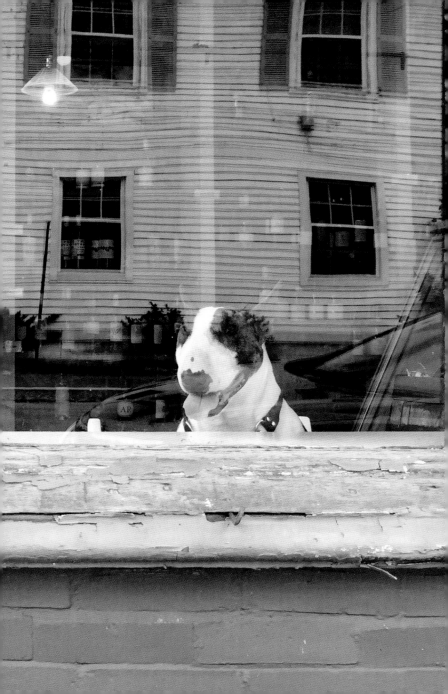

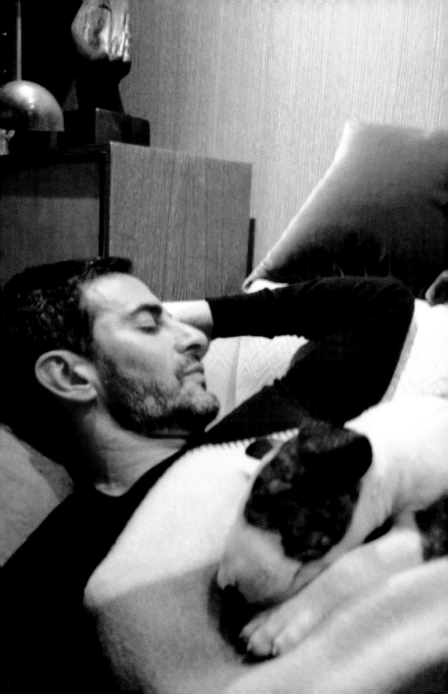

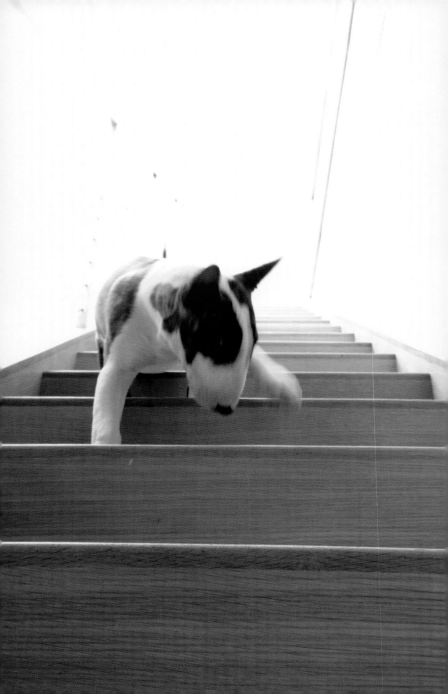

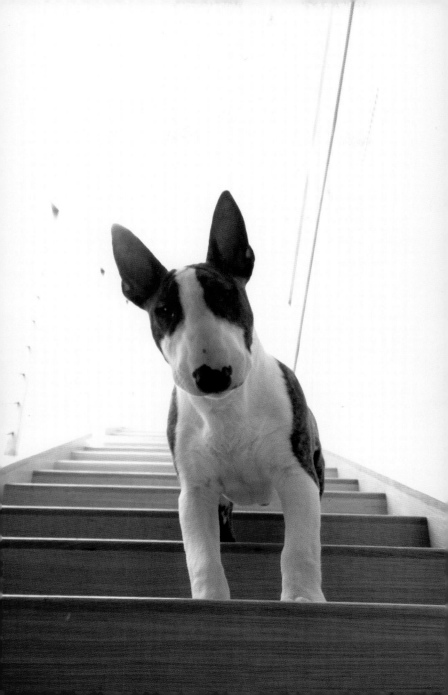

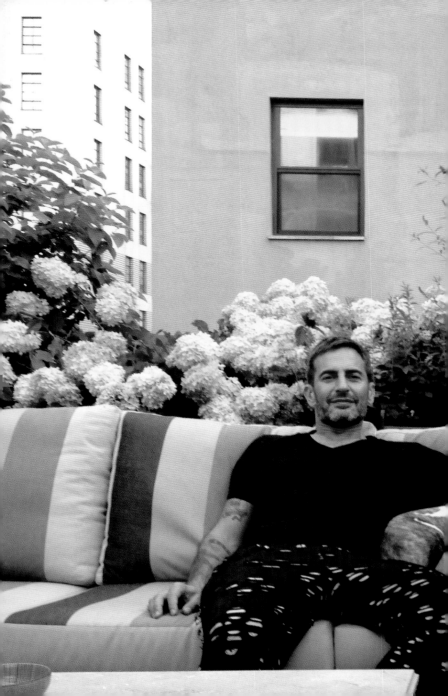

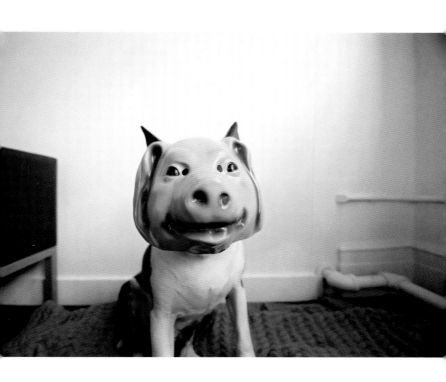

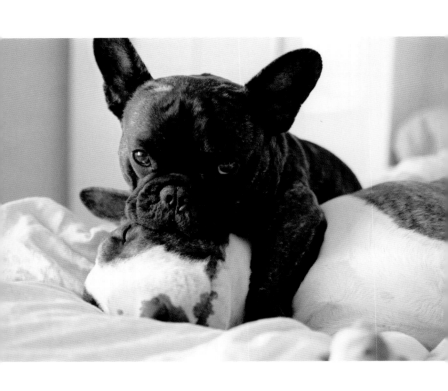

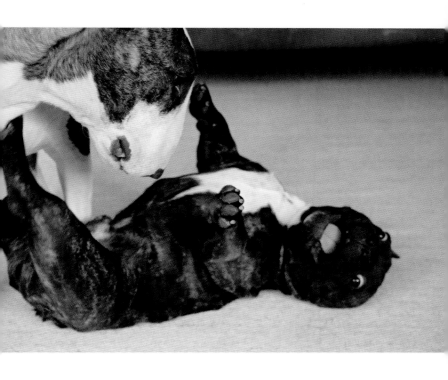

THIS IS MY BEST FRIEND AND
BROTHER FROM ANOTHER MOTHER (AND FATHER),
CHOO CHOO CHARLIE!

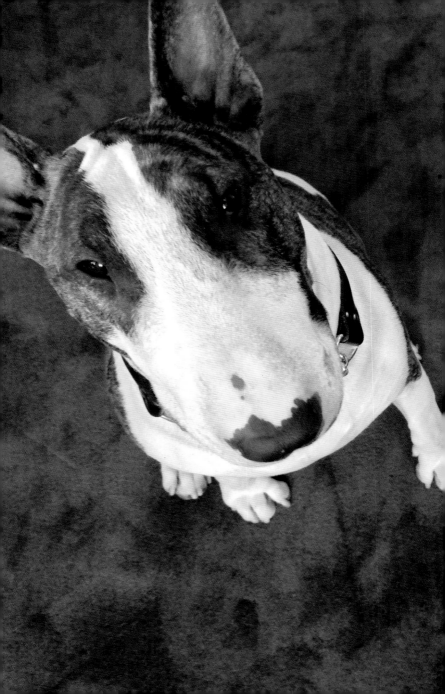

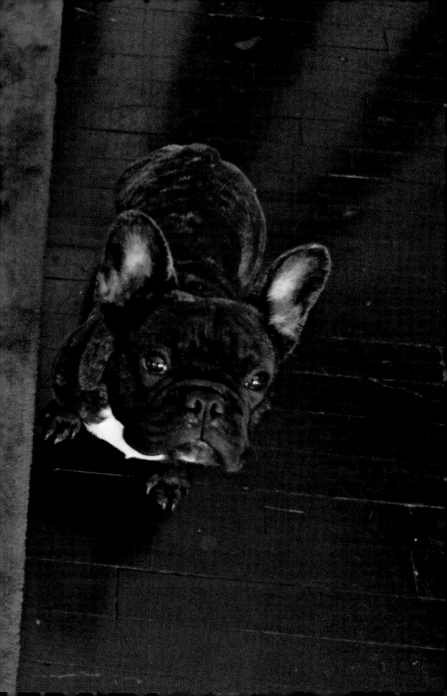

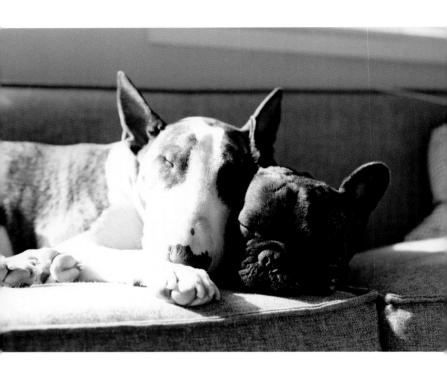

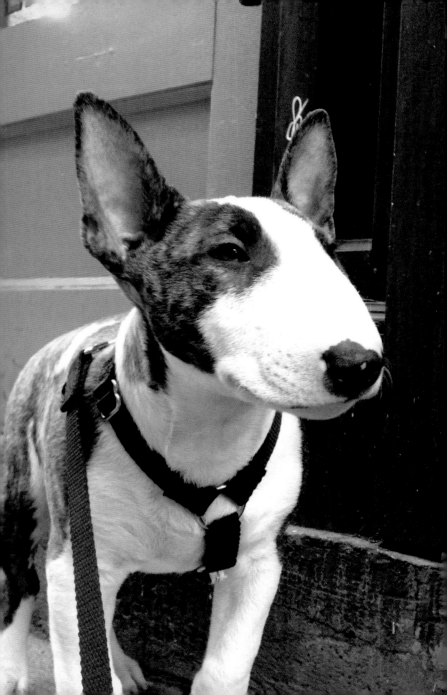

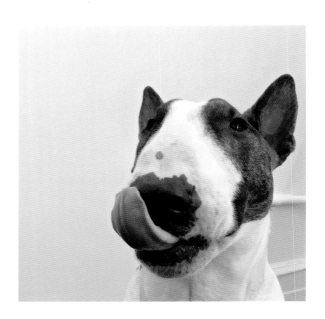
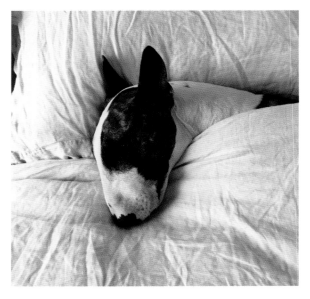

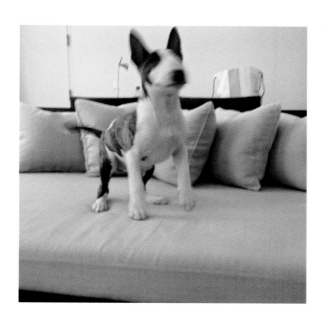

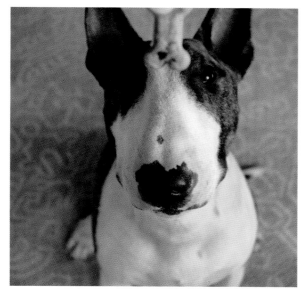

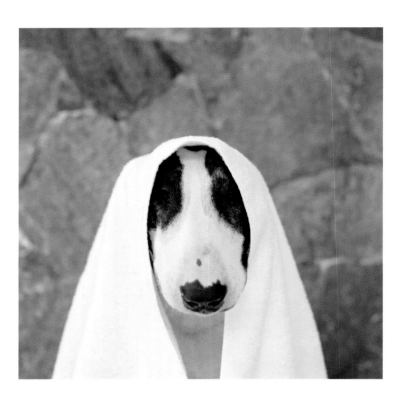

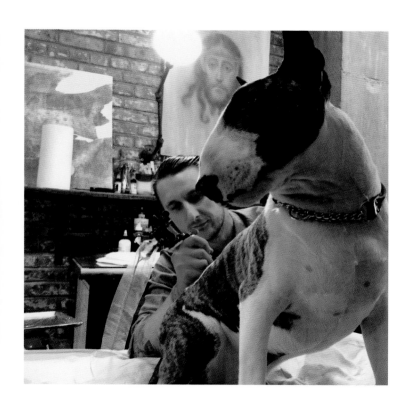

BROS BEFORE BITCHES!
MY FIRST TATTOO FROM MY GOOD FRIEND,
SCOTT CAMPBELL.

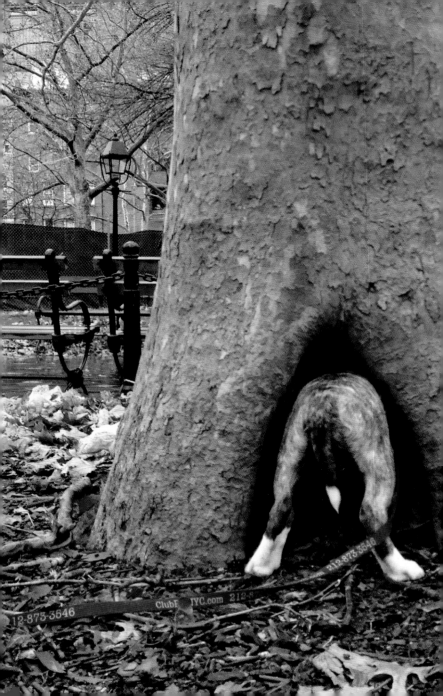

I GET TO WORK WITH A LOT OF REALLY BEAUTIFUL
WOMEN IN FASHION, IN LARGE PART DUE TO MY GOOD FRIEND,
KATIE GRAND. THIS IS ME WITH HANNE GABY ODIELE.
WE OFTEN RUN INTO EACH OTHER IN THE NEIGHBORHOOD.

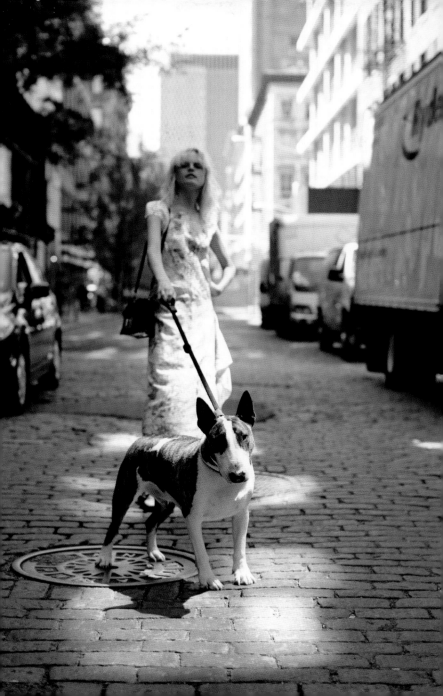

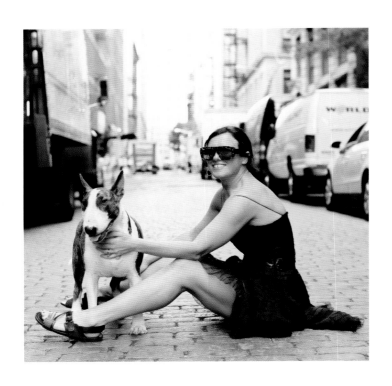

KATIE GRAND!

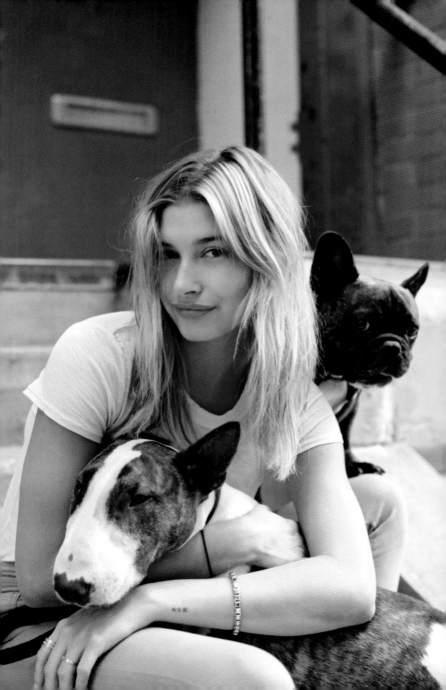

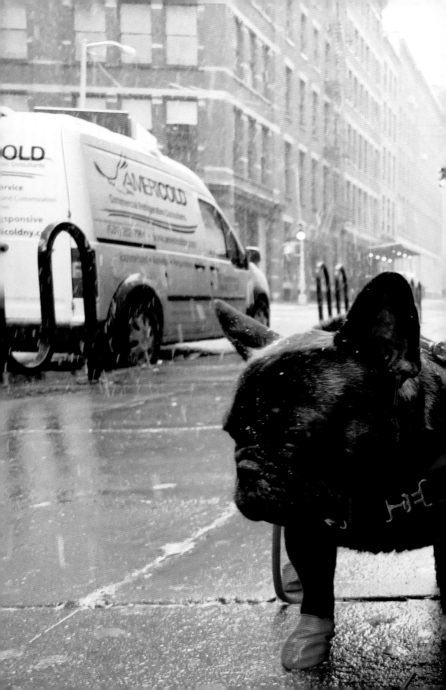

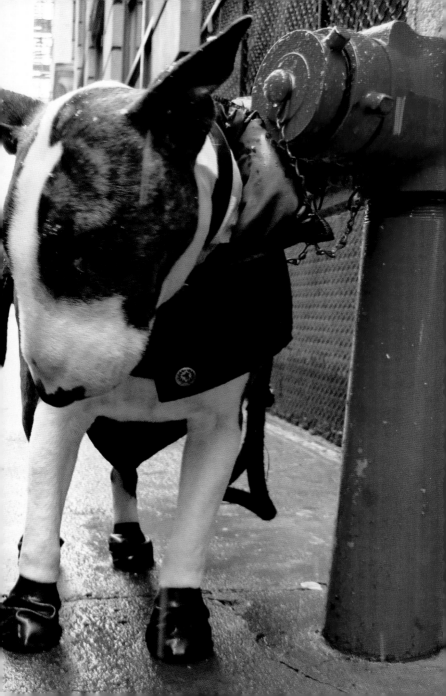

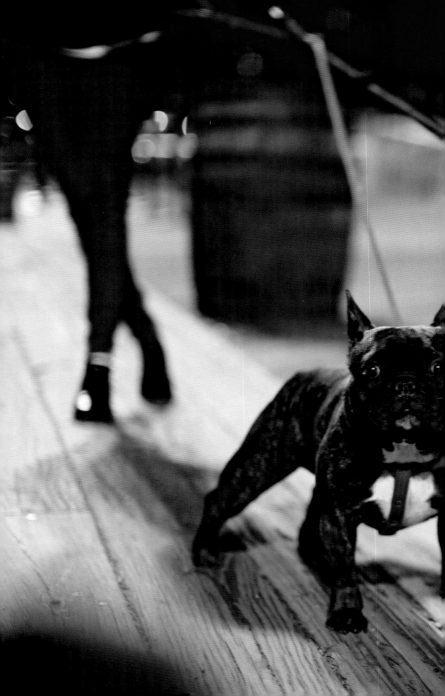

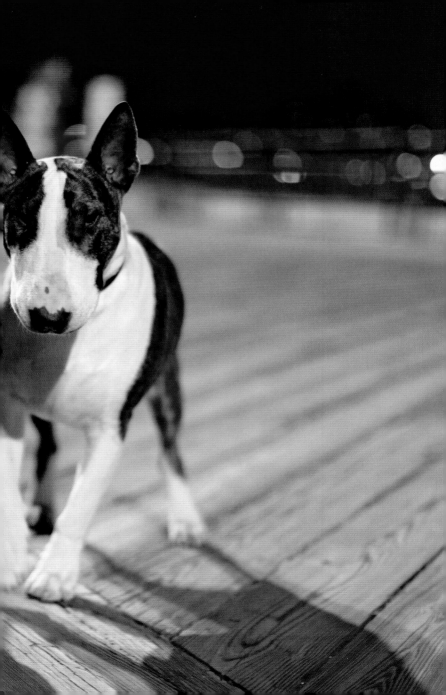

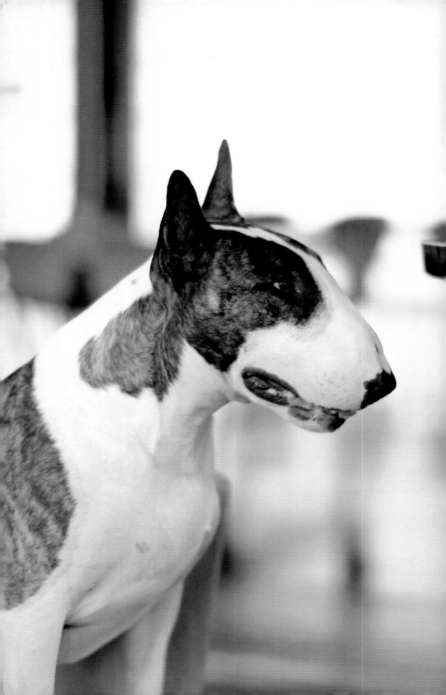

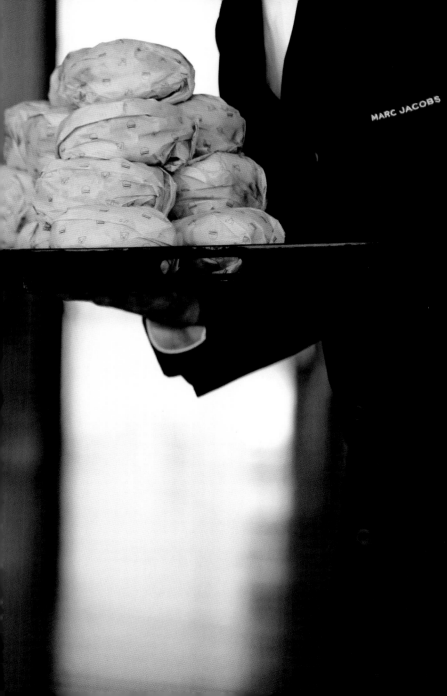

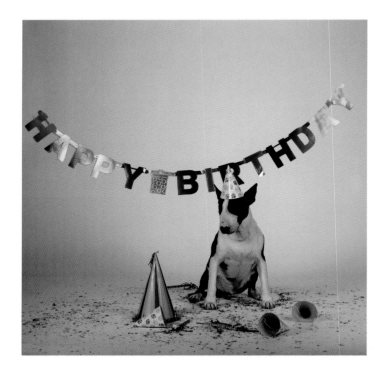

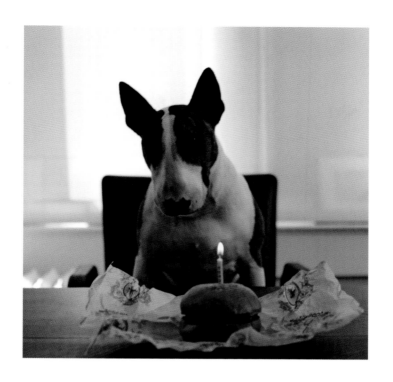

IT'S BECOME A TRADITION
TO EAT BURGERS ON MY BIRTHDAY.

ANOTHER YEAR, ANOTHER BURGER...

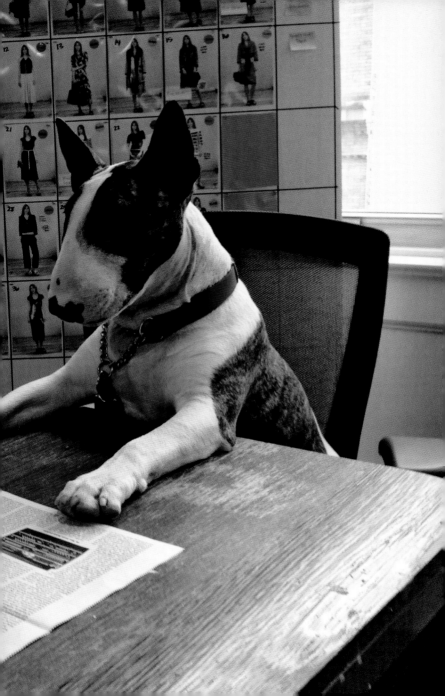

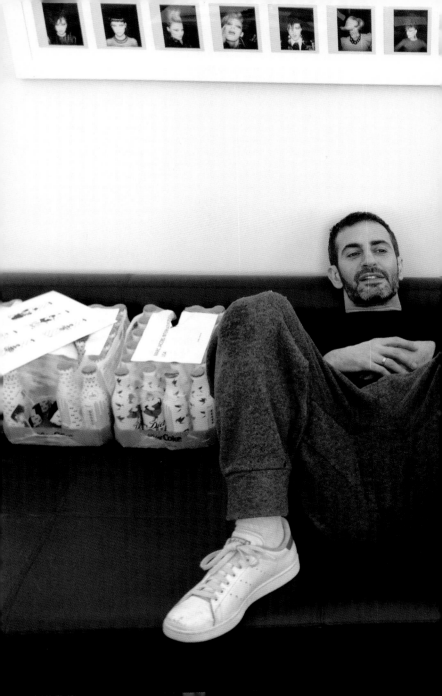

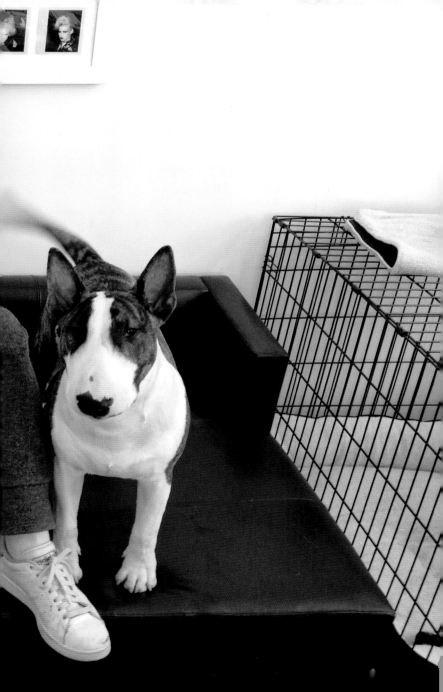

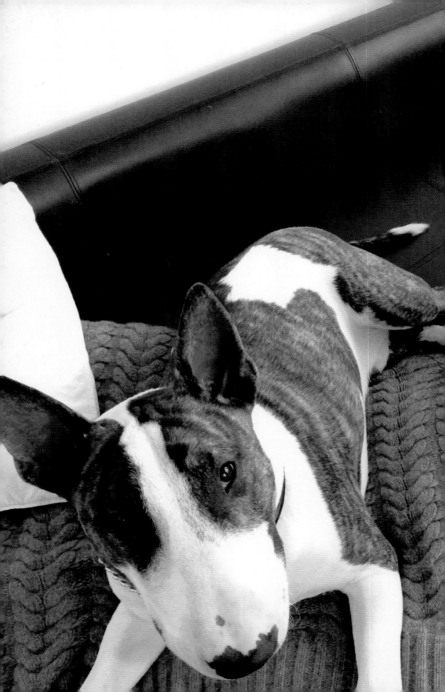

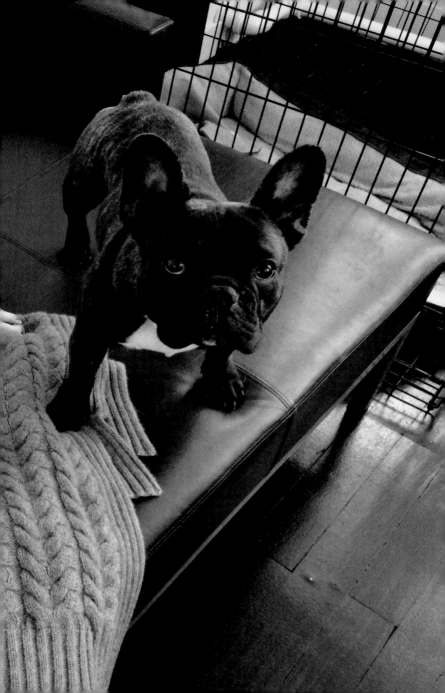

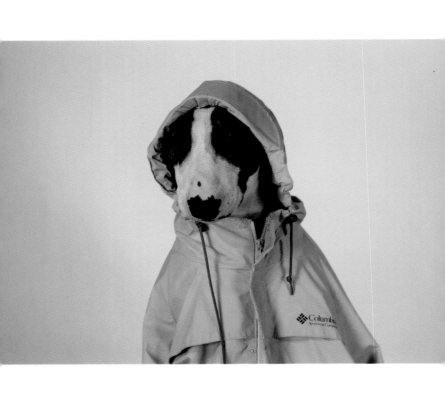

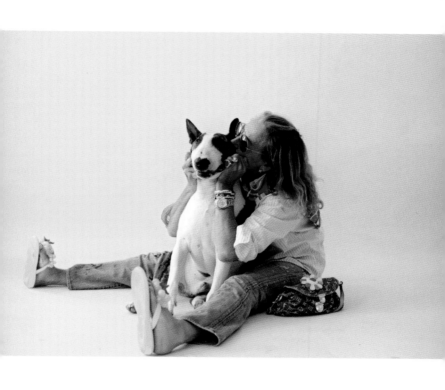

THIS IS CARLYNE CERF DE DUDZEELE.
NOT ONLY IS SHE A LEGEND IN THE FASHION WORLD,
SHE'S ALSO MY SOUL MATE.

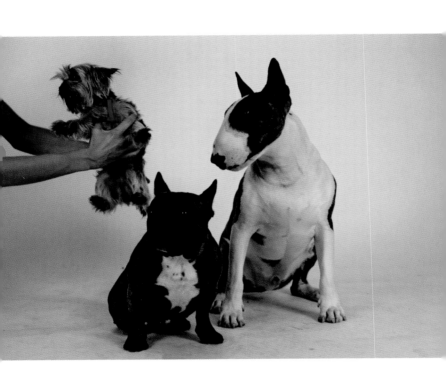

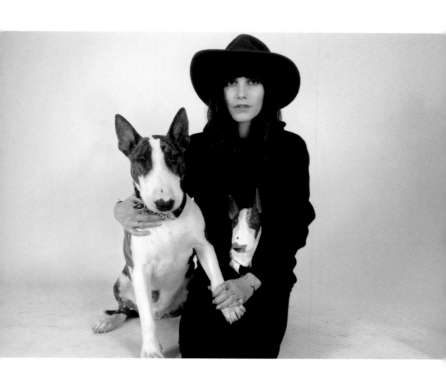

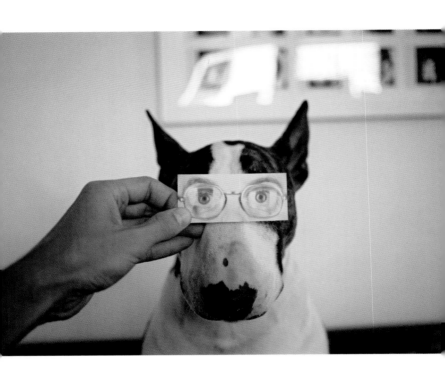

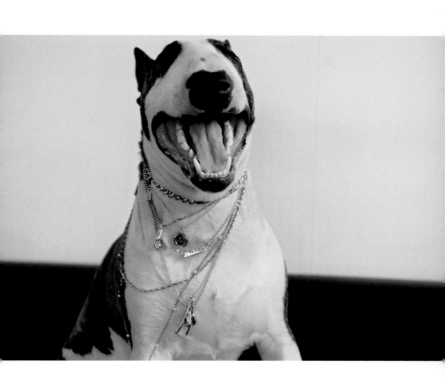

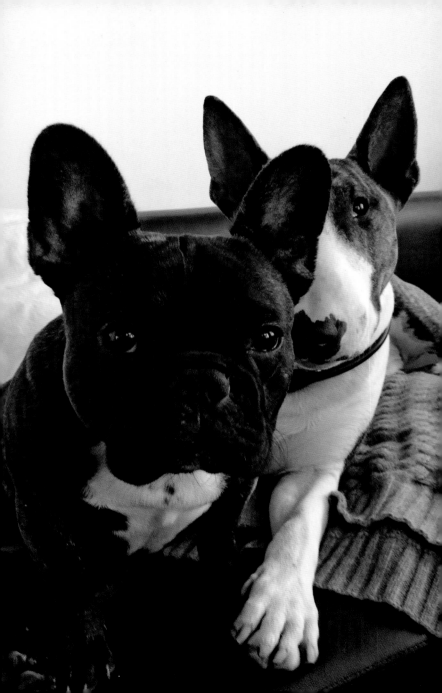

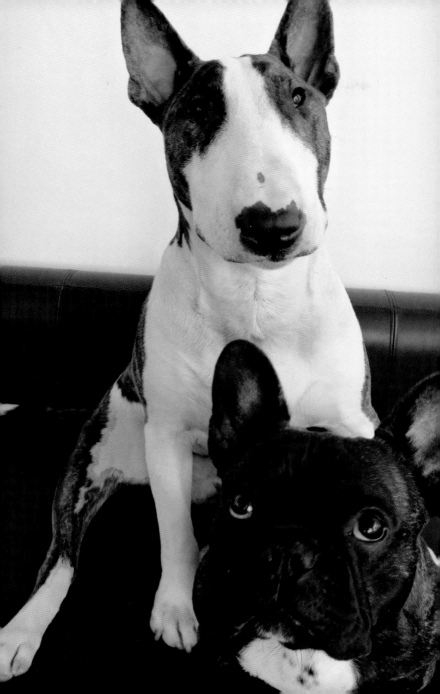

HOUNDSTOOTH.

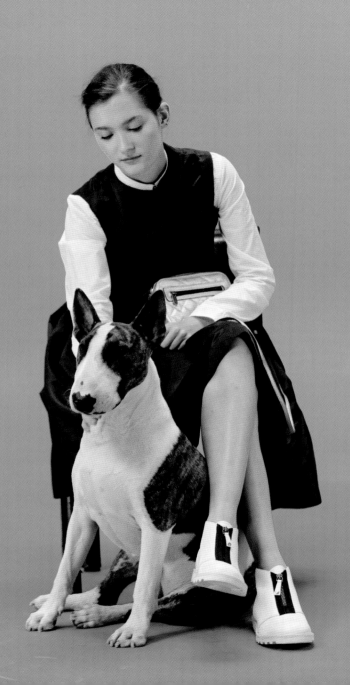

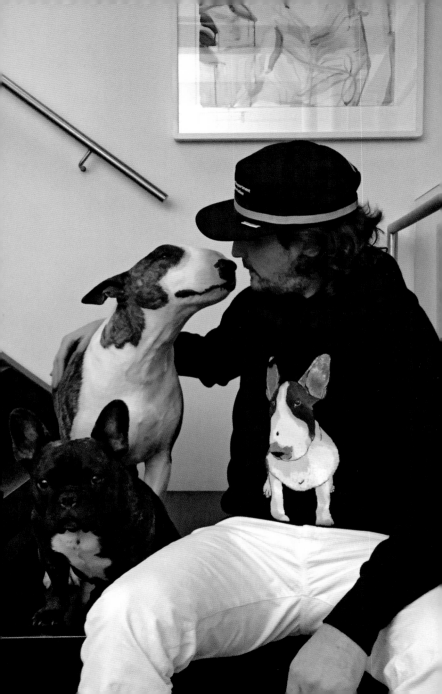

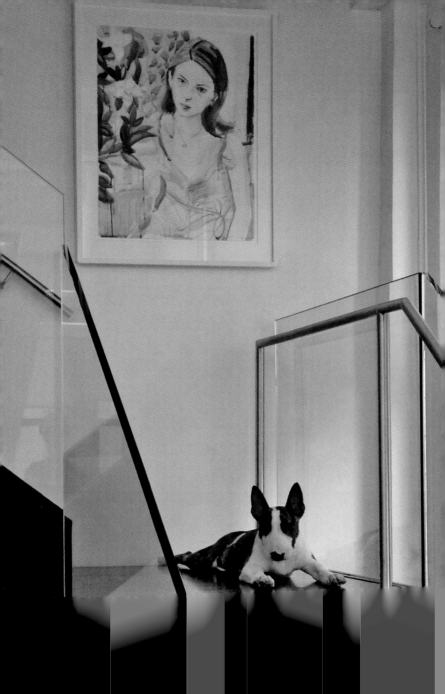

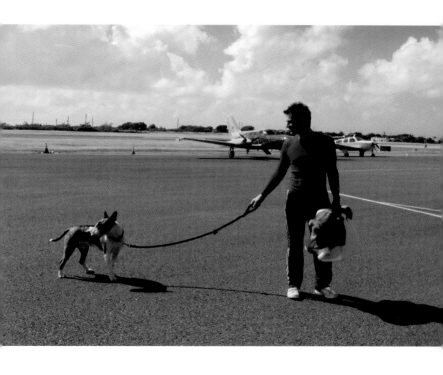

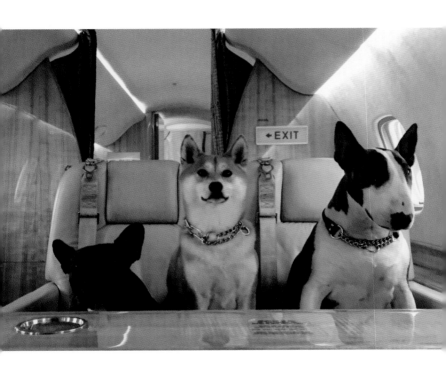

SEE YOU IN A COUPLE OF WEEKS, NEW YORK.

TIME FOR SOME FUN IN THE SUN!

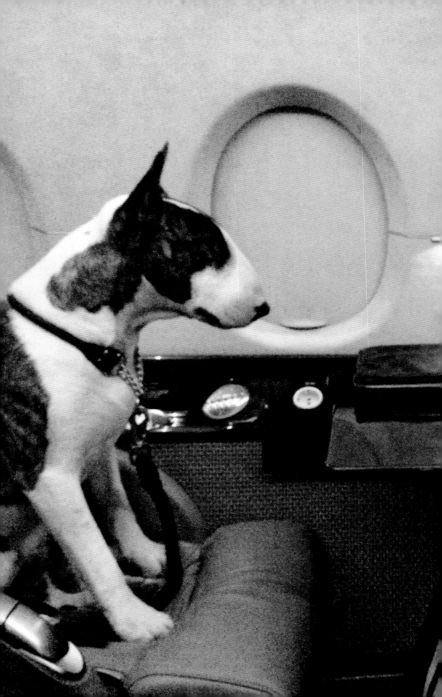

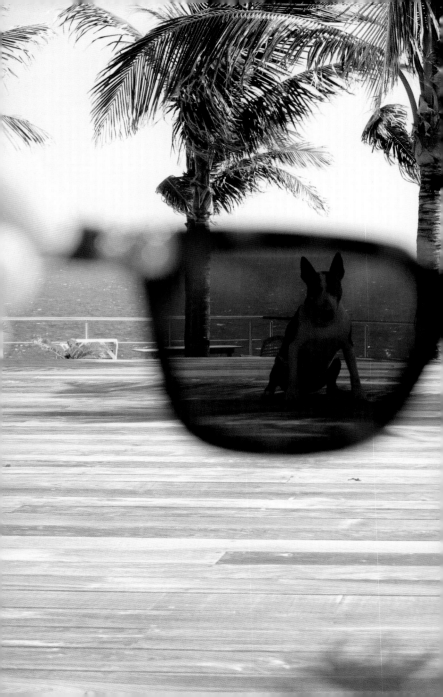

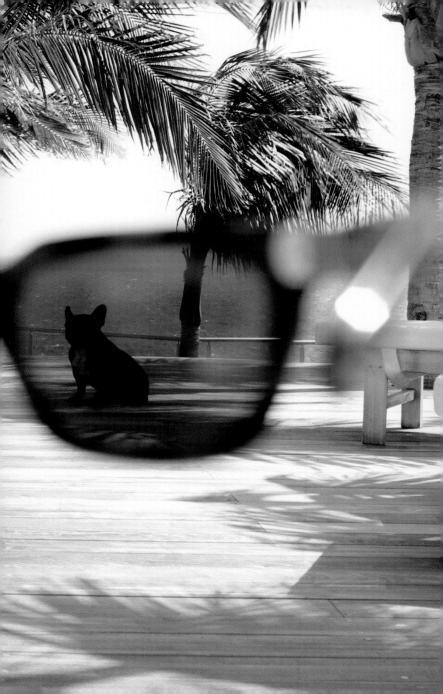

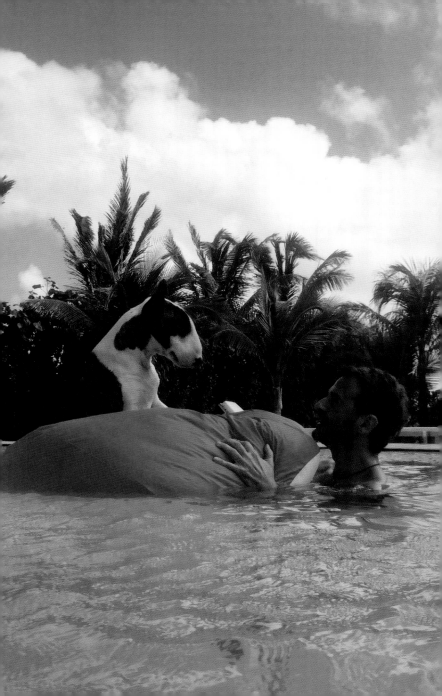

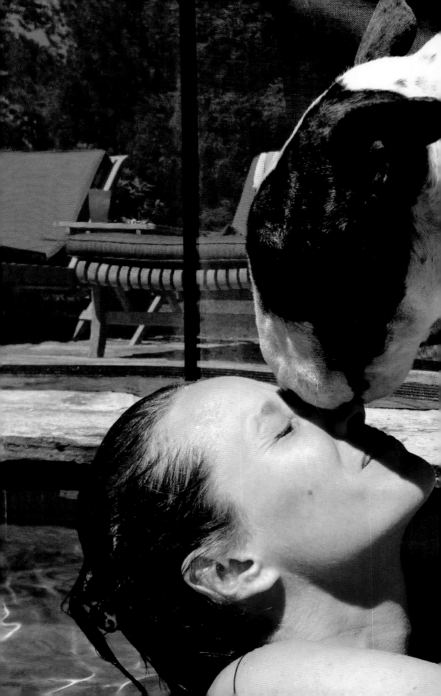

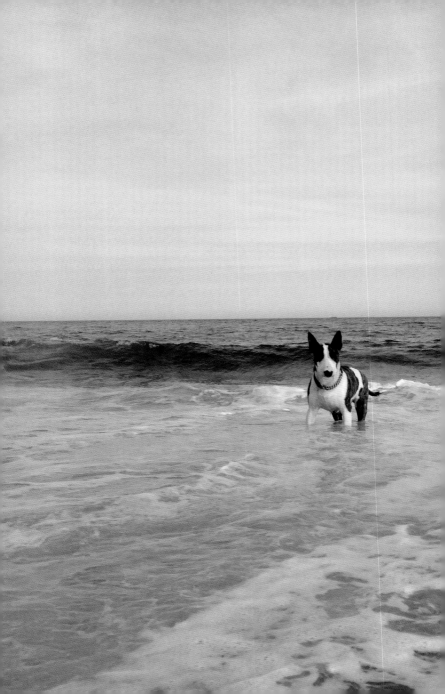

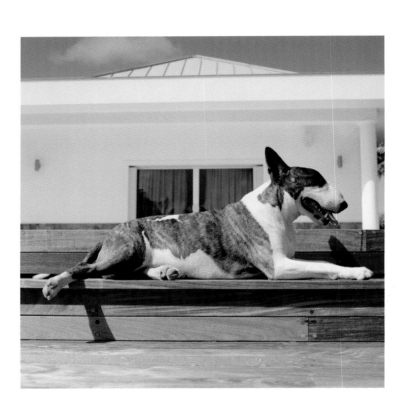

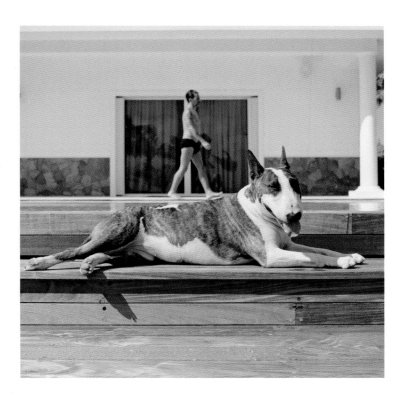

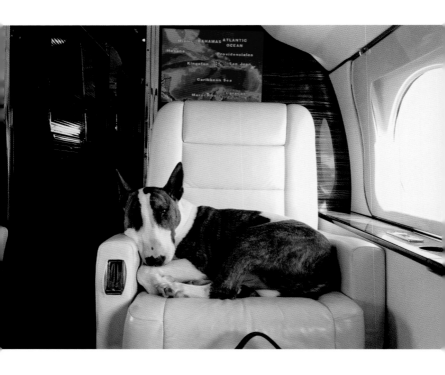

HEADING HOME FROM SUNNY ST. BARTH'S.
NOT LOOKING FORWARD TO THE COLD OR THE
WORKLOAD BEFORE FASHION WEEK.

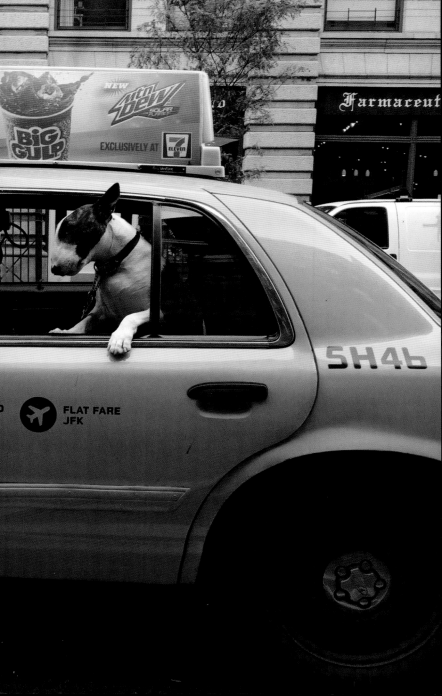

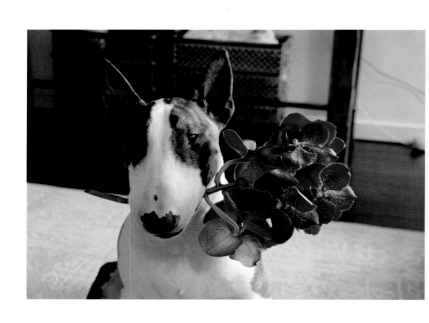

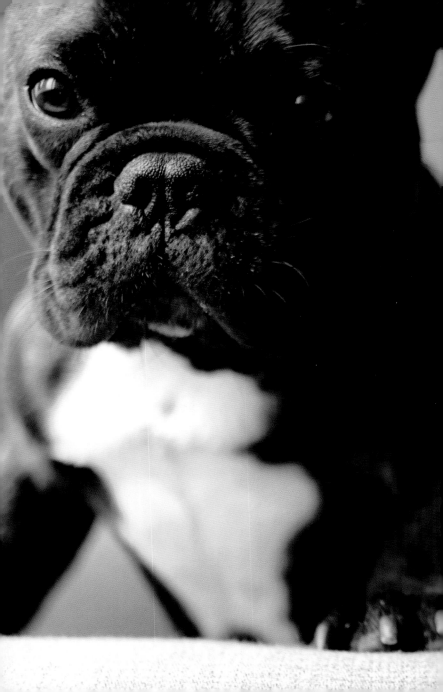

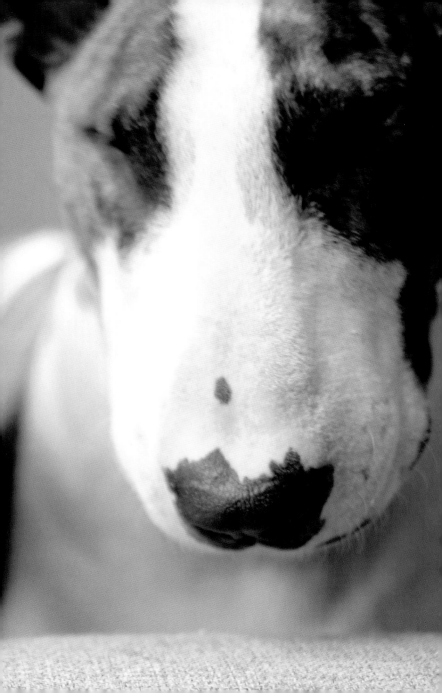

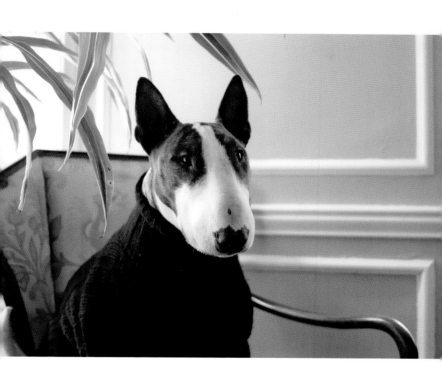

FEELING VERY ENGLISH TODAY IN THE COUNTRYSIDE.

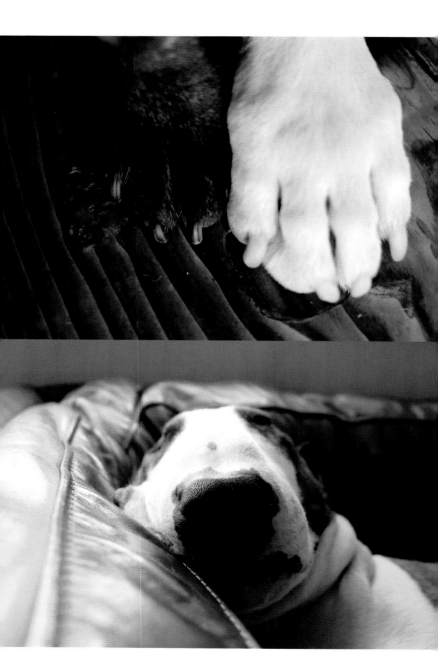

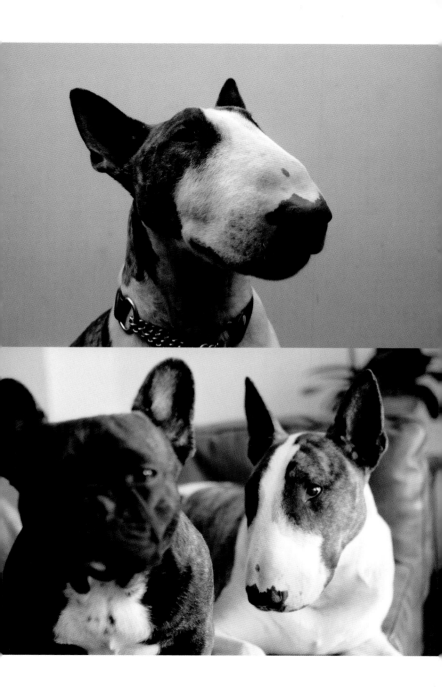

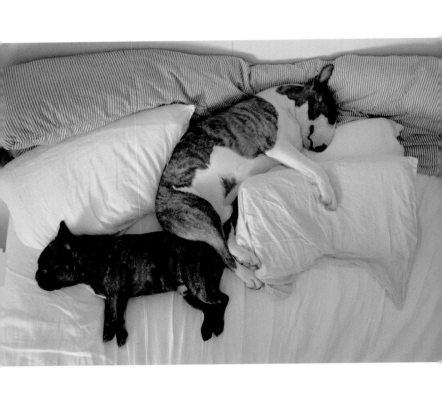

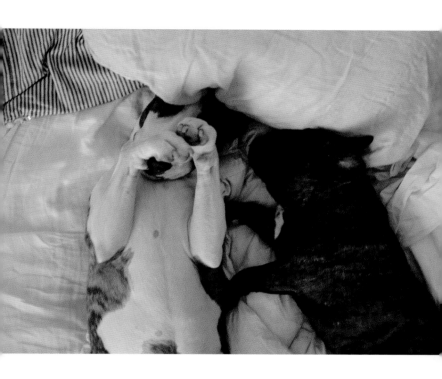

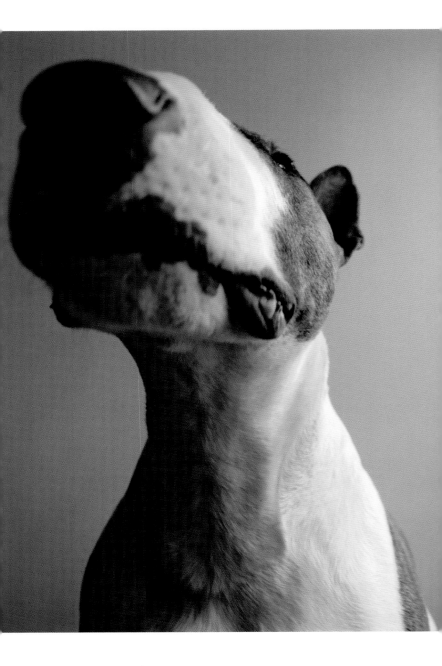

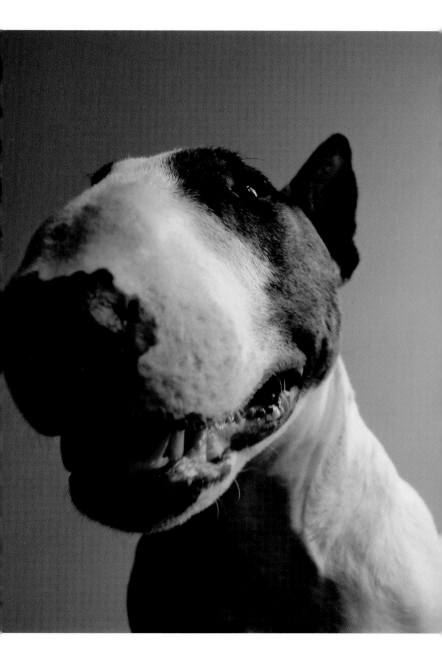

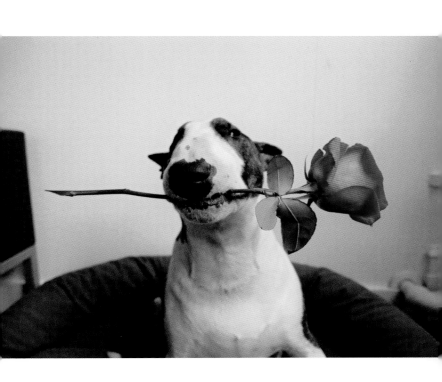

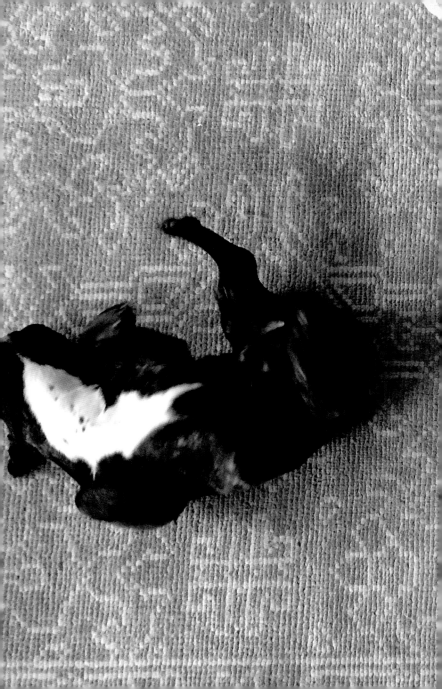

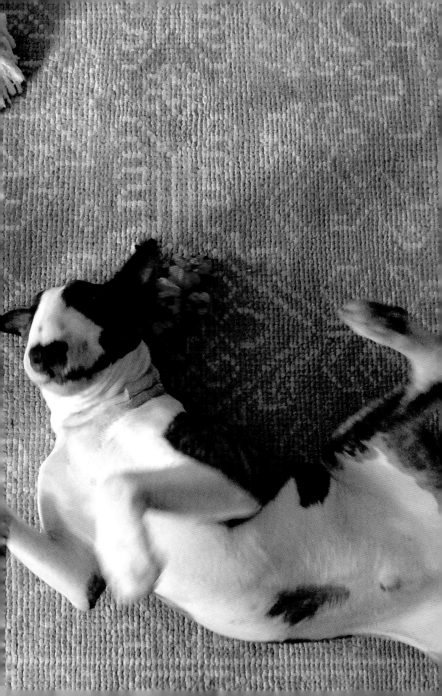

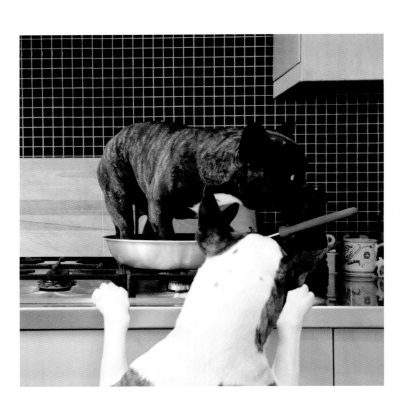

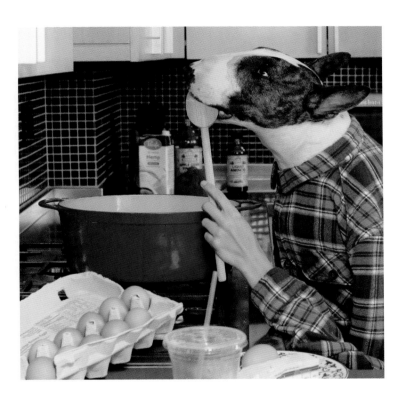

DIET ON FLEEK.

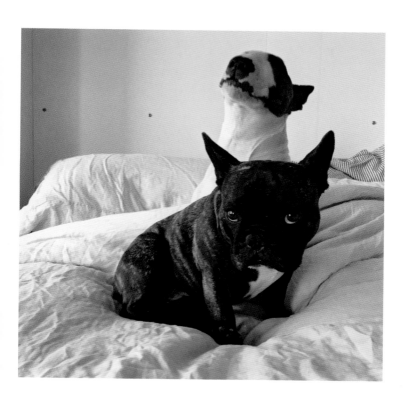

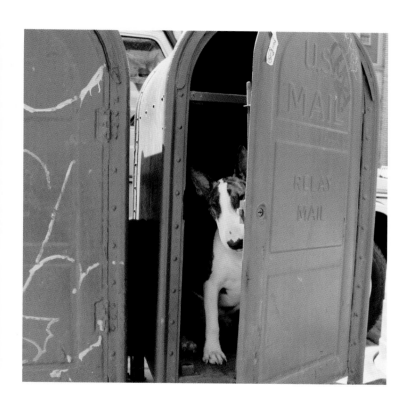

FIRST CLASS, PLEASE!

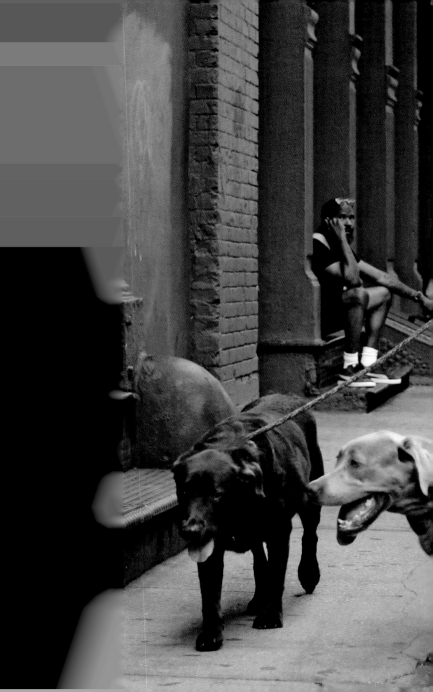

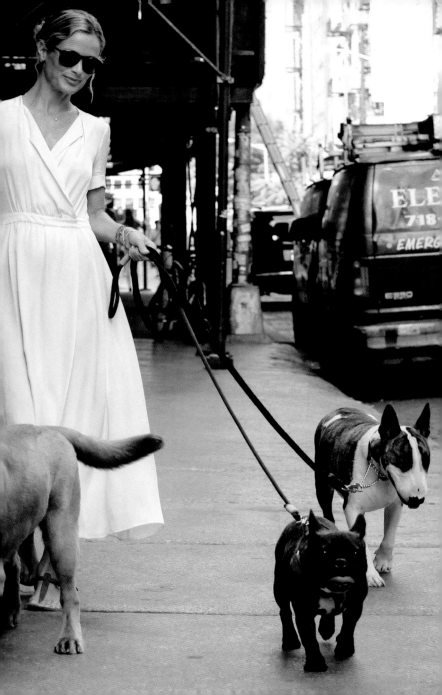

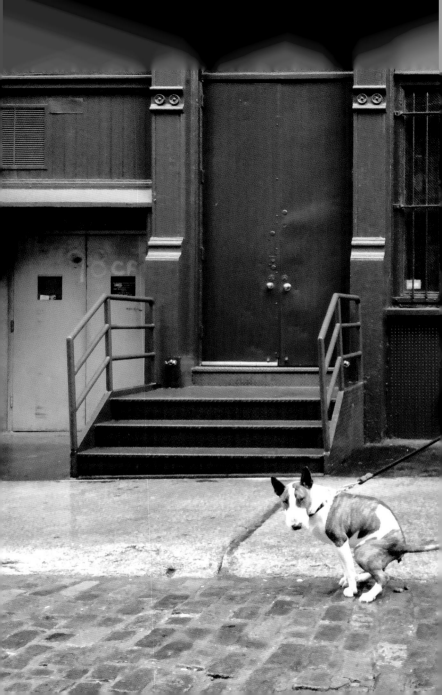

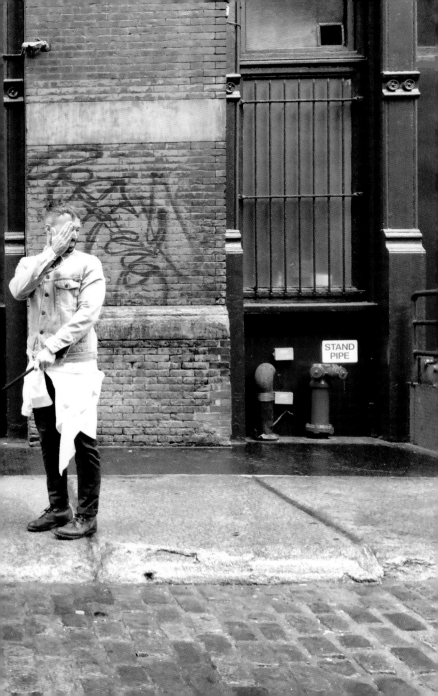

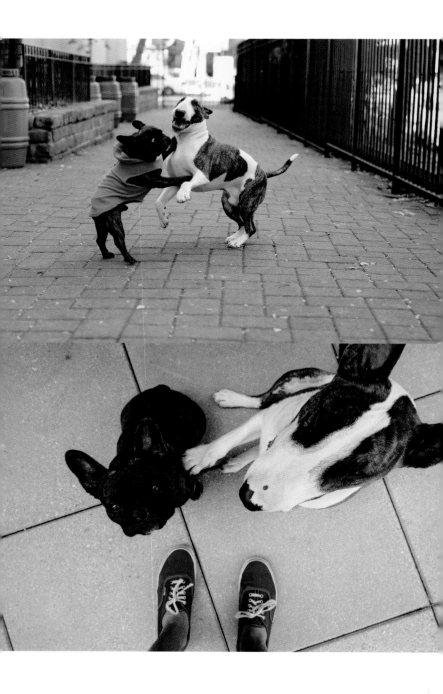

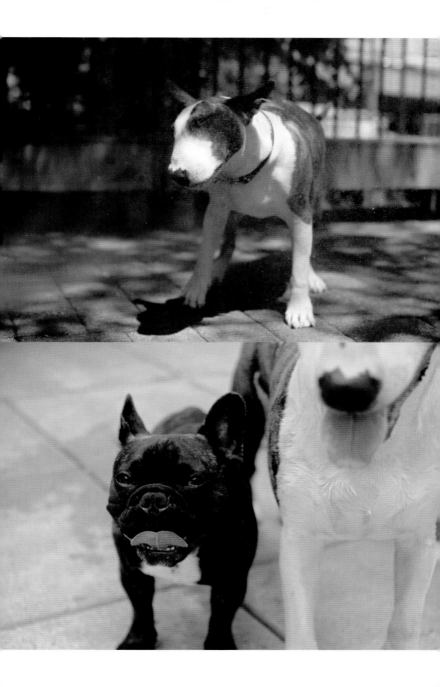

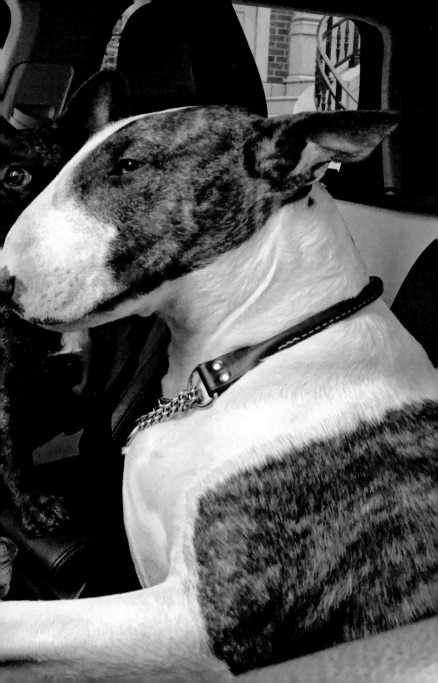

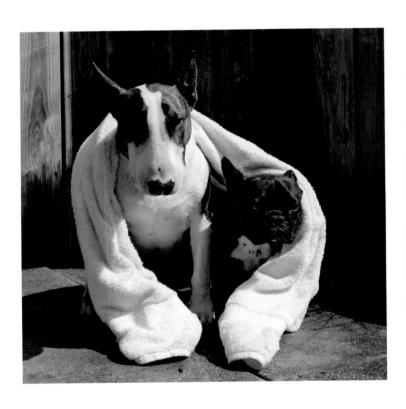

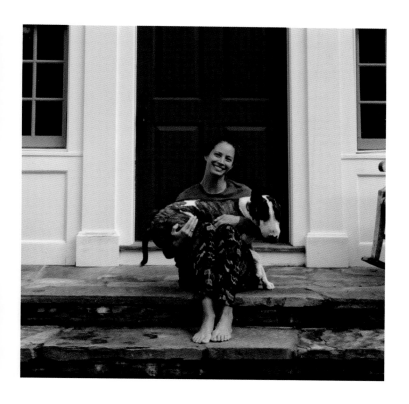

MY WEEKEND IN THE COUNTRY WITH
THE ONE AND ONLY CHRISTY TURLINGTON.

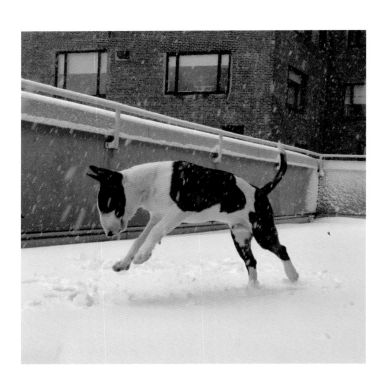

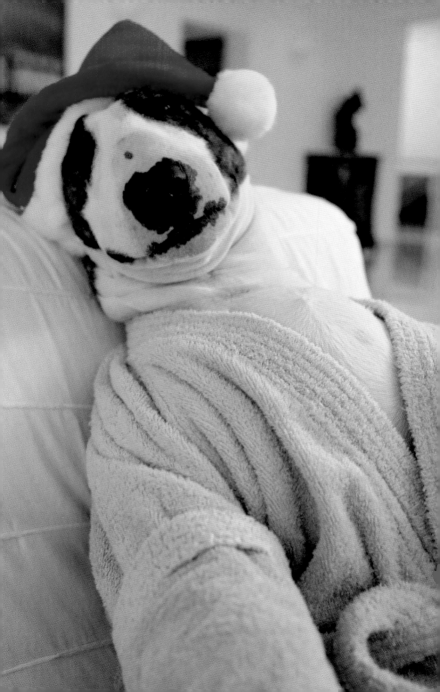

WORKING LATE NIGHTS
WITH DAD IN THE DESIGN STUDIO.

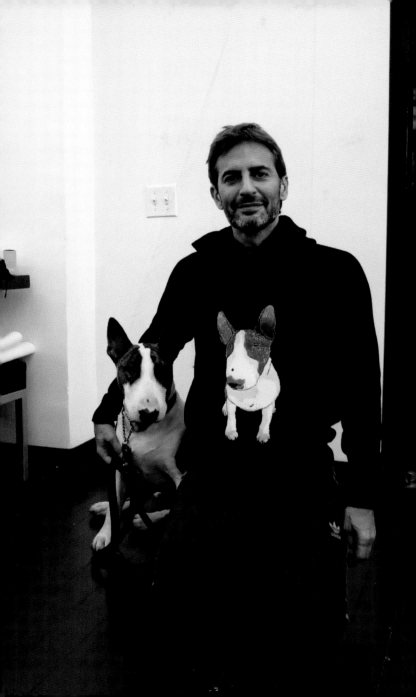

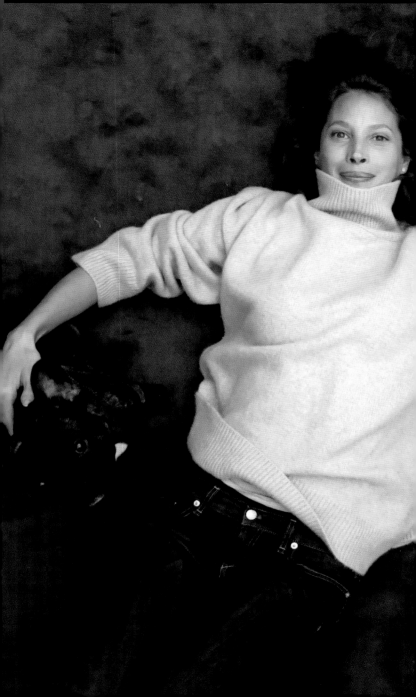

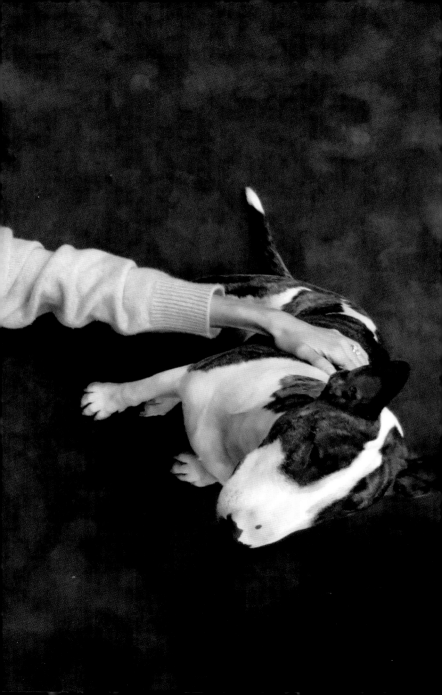

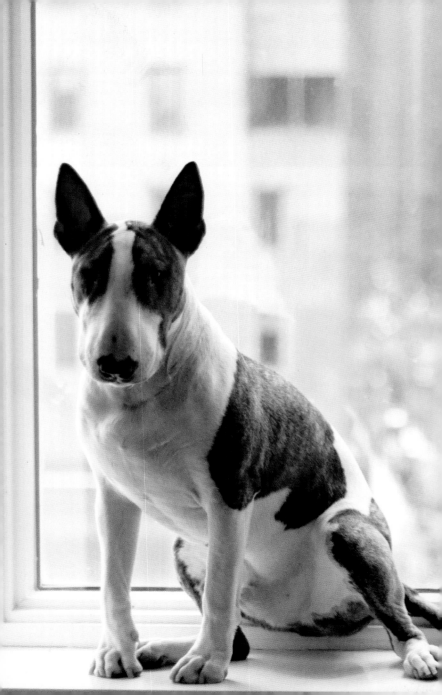

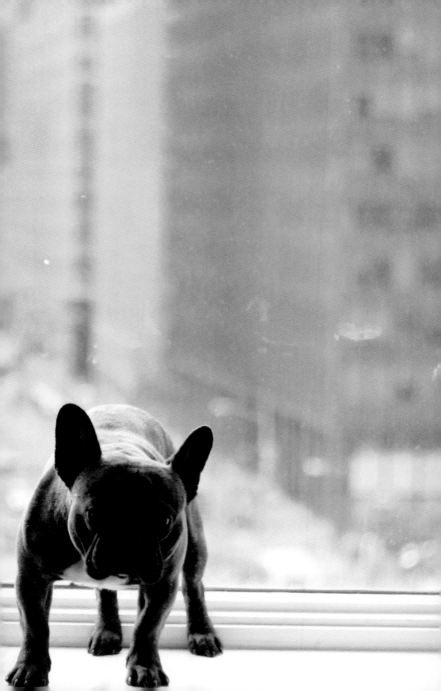

IT ALWAYS DOES.

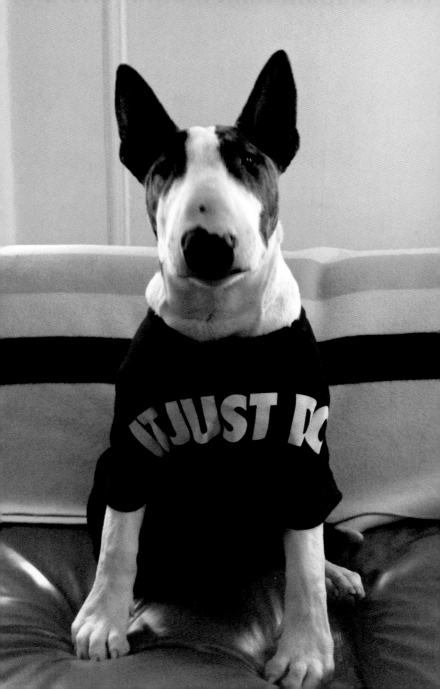

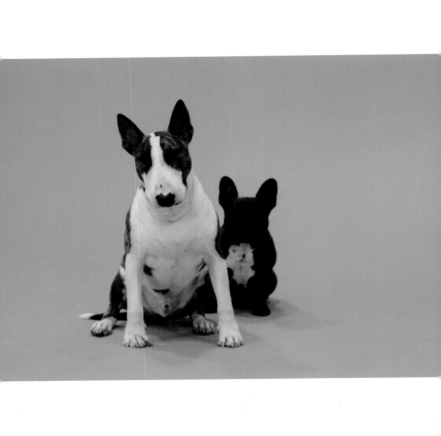

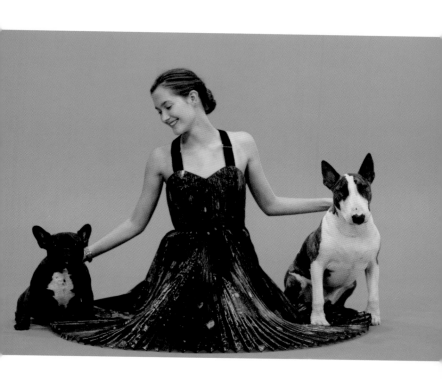

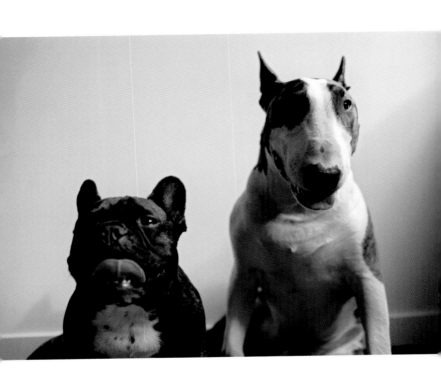

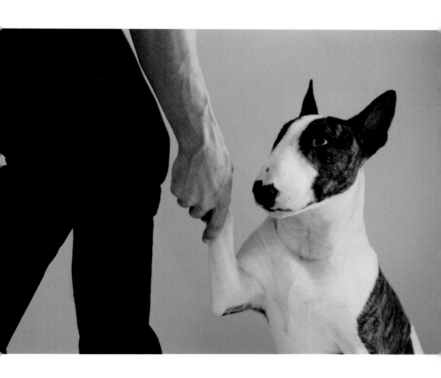

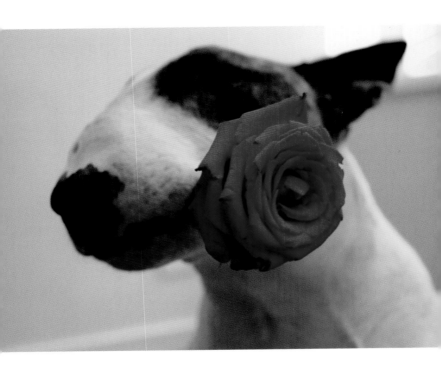

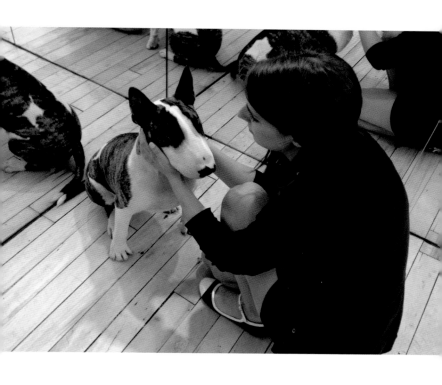

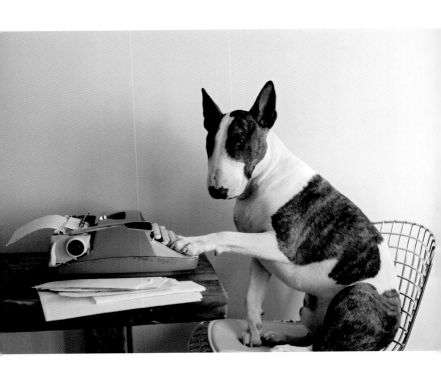

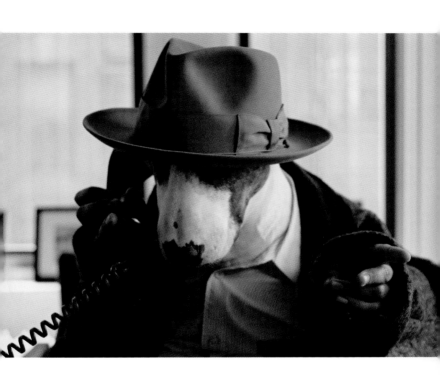

THIS PHONE NEVER STOPS RINGING!

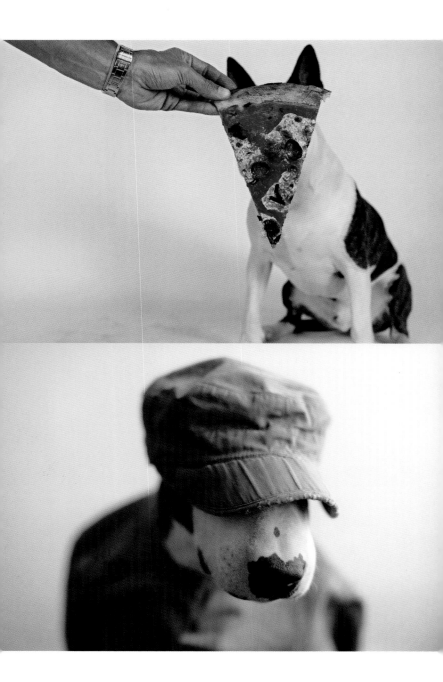

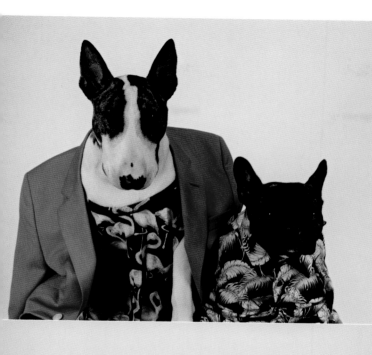

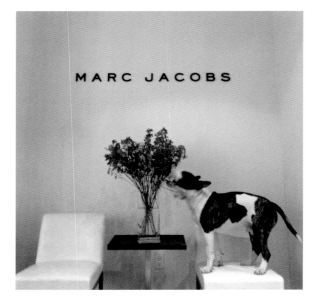

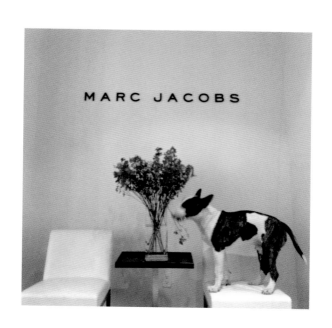

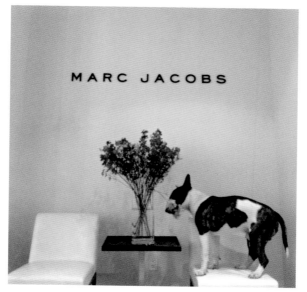

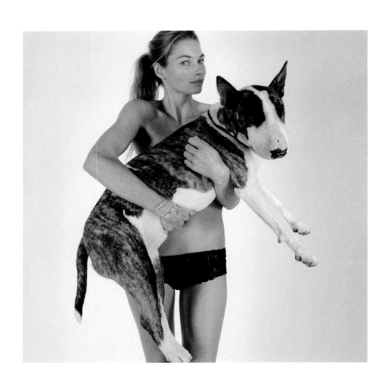

I HEART JESSICA HART.

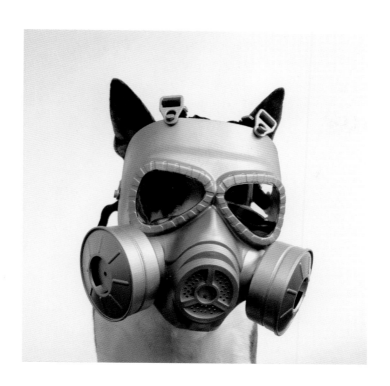

TWO WORDS:

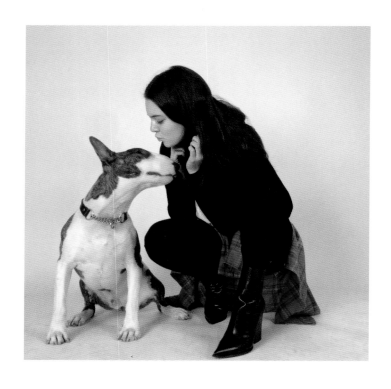

KENDALL JENNER.

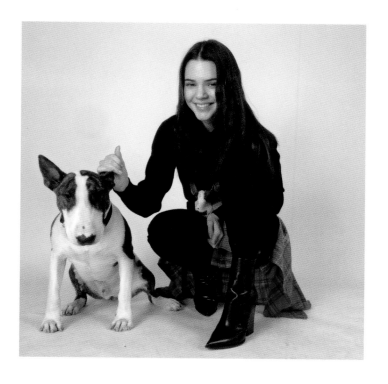

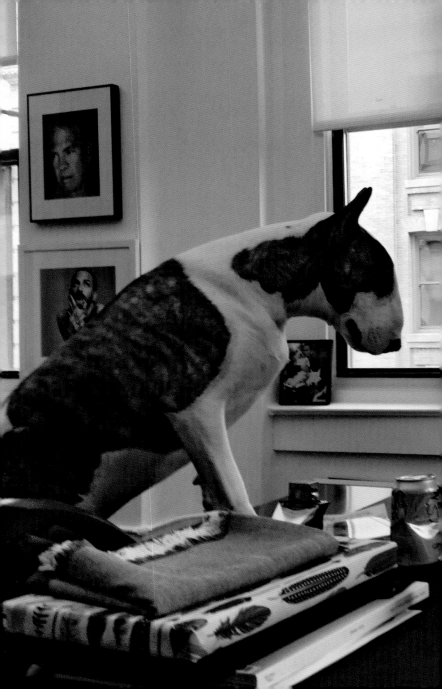

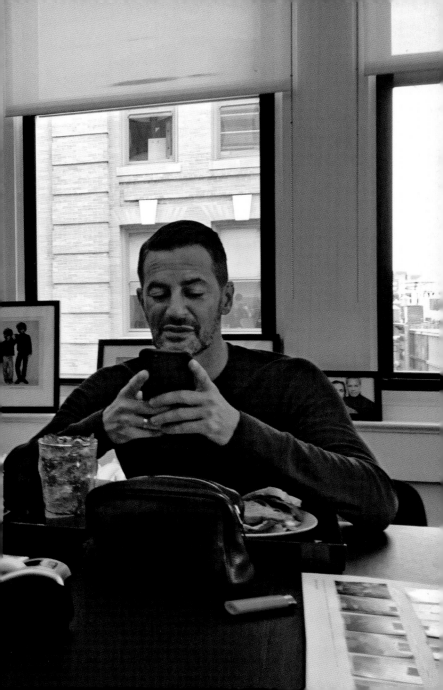

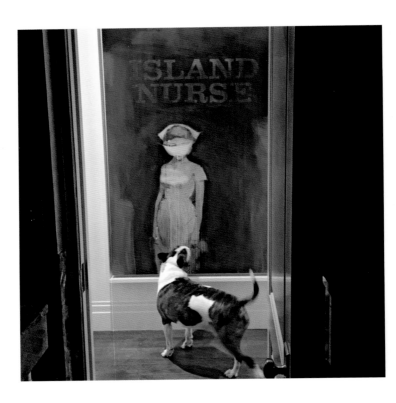

IN THE PEACE AND QUIET AT HOME WITH DAD:
MY FAVORITE PLACE ON EARTH.

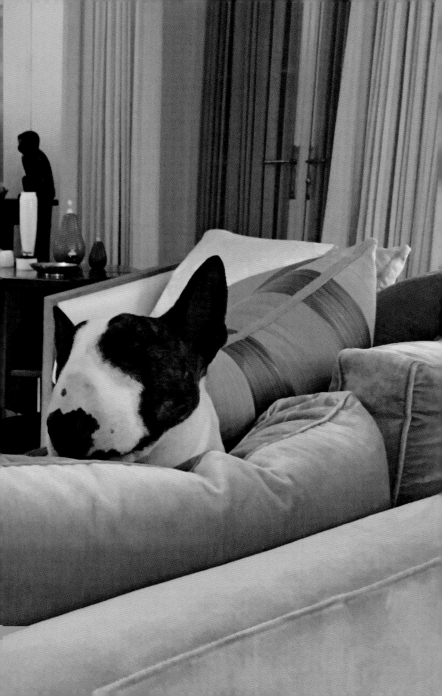

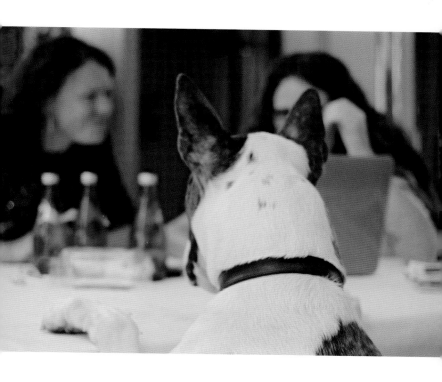

LUNCH MEETINGS ARE ALWAYS IMPORTANT.
LUNCH MEETINGS WITH KARLIE KLOSS ARE EVEN MORE
IMPORTANT—MOSTLY BECAUSE SHE BRINGS TREATS.

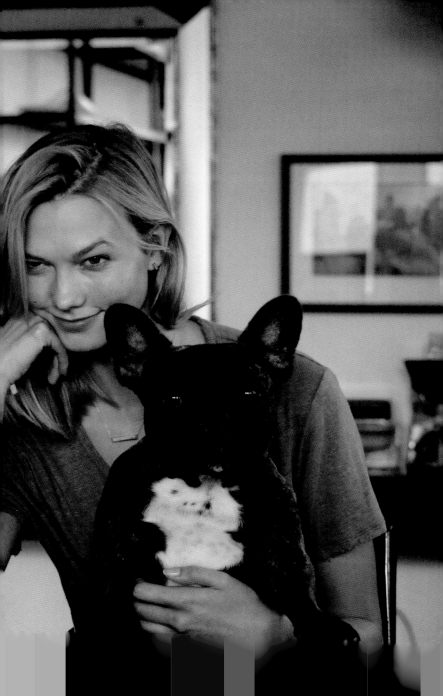

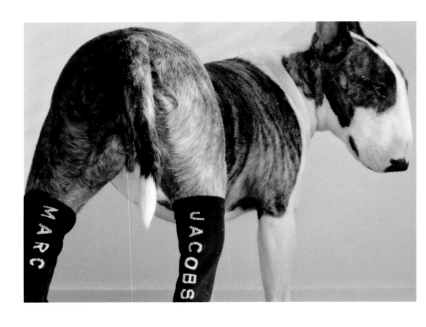

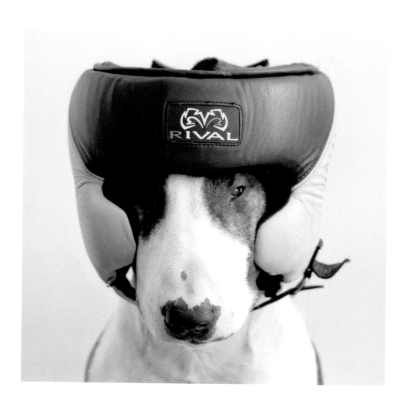

I'LL NEVER BE A BOXER.

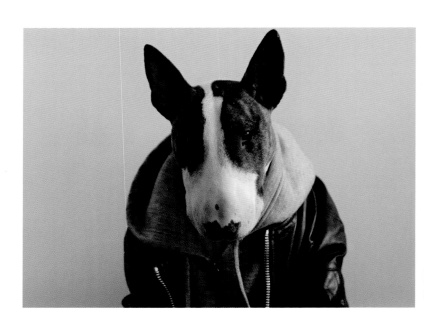

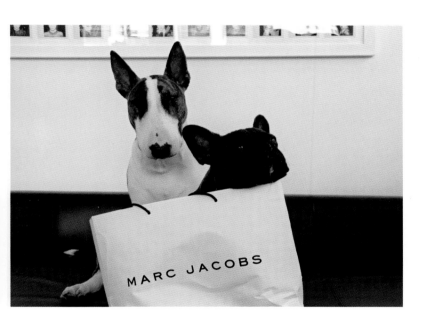

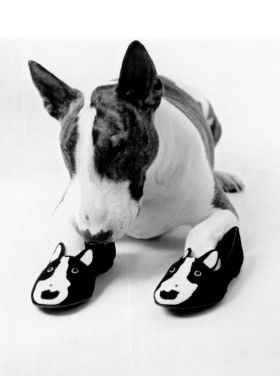

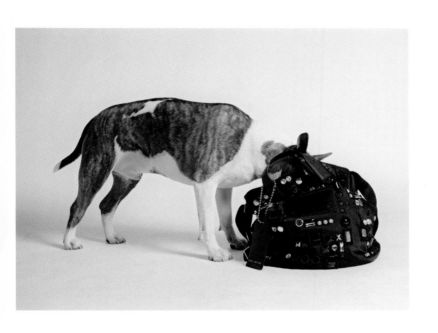

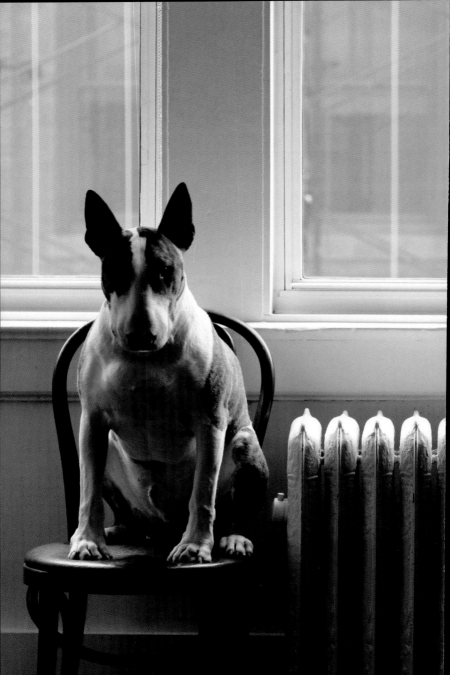

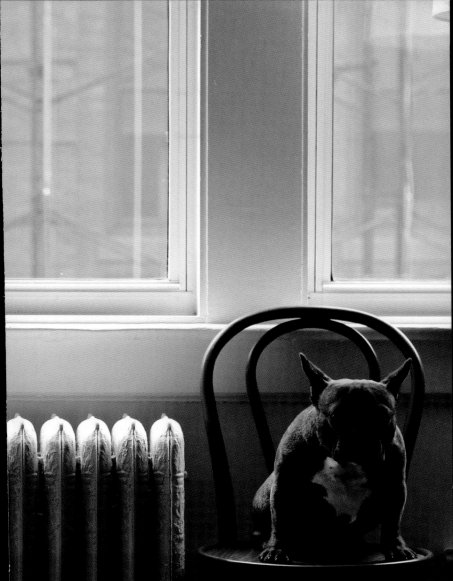

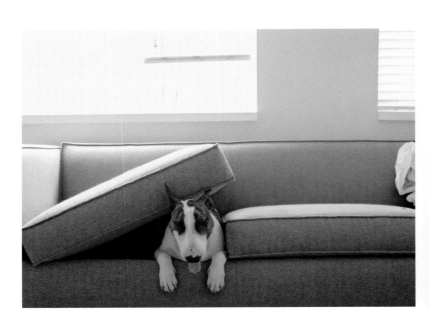

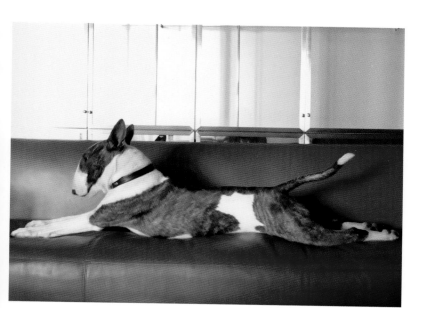

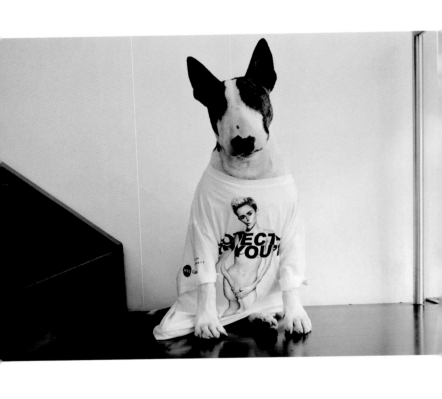

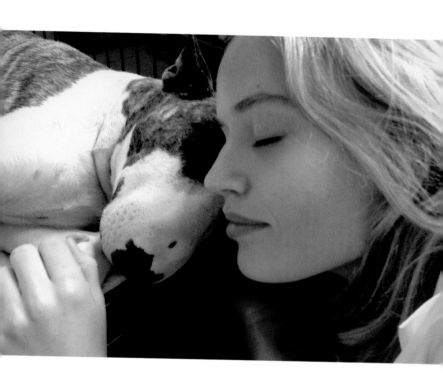

GEORGIA MAY JAGGER AND I,
NAPPING BETWEEN FITTINGS.

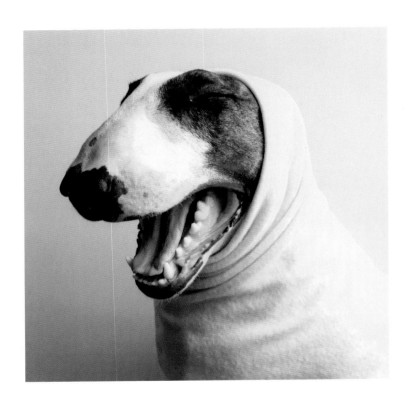

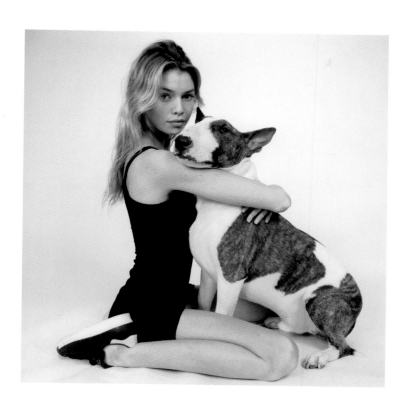

STELLA MAXWELL + NEVILLE JACOBS 4EVA.
UNLIKE THAT TIME I KIDNAPPED CARA DELEVINGNE
DURING NEW YORK FASHION WEEK.

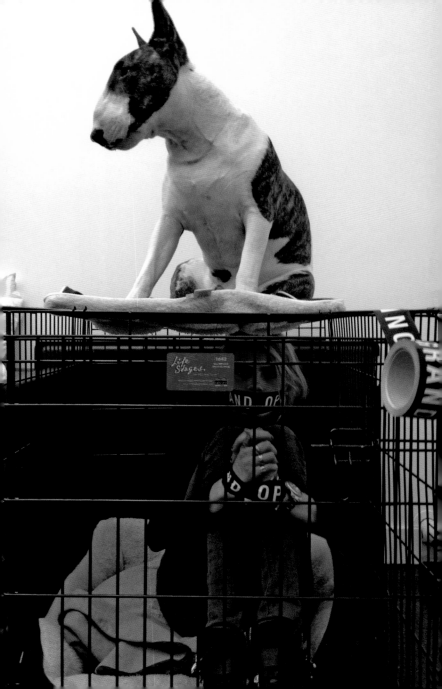

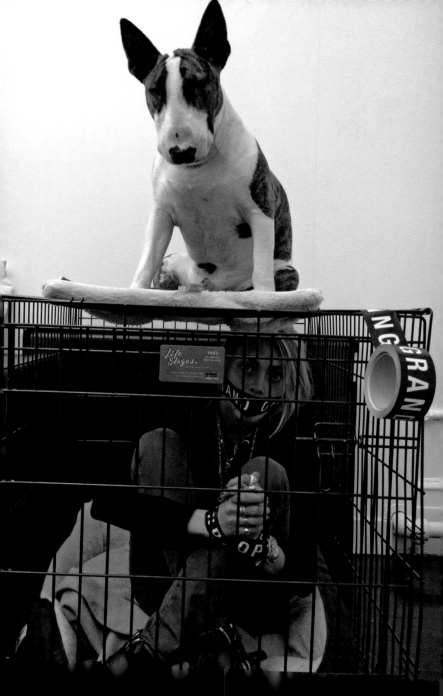

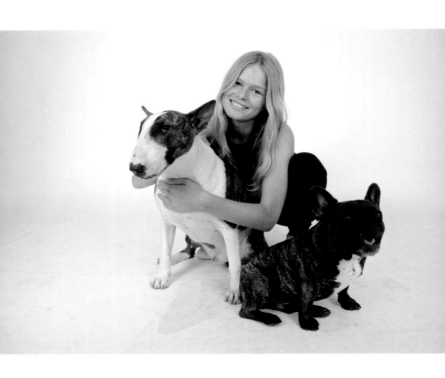

ANNA EWERS + NEVILLE JACOBS + CHARLIE
= HAPPINESS EVER AFTER.

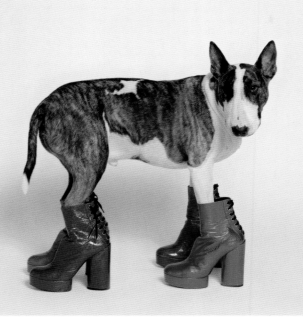

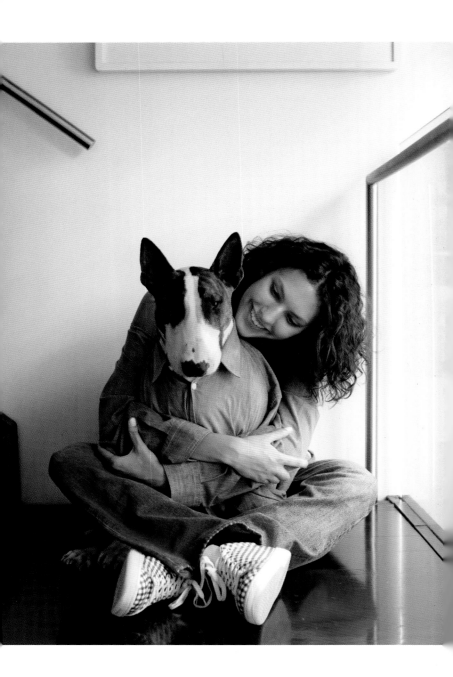

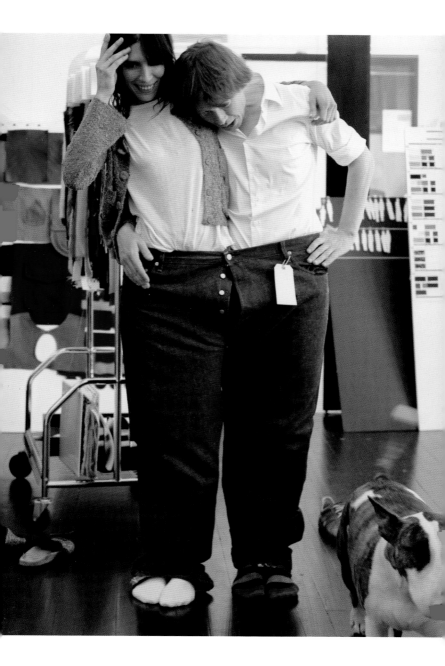

ADRIANA LIMA. NEED I SAY MORE?

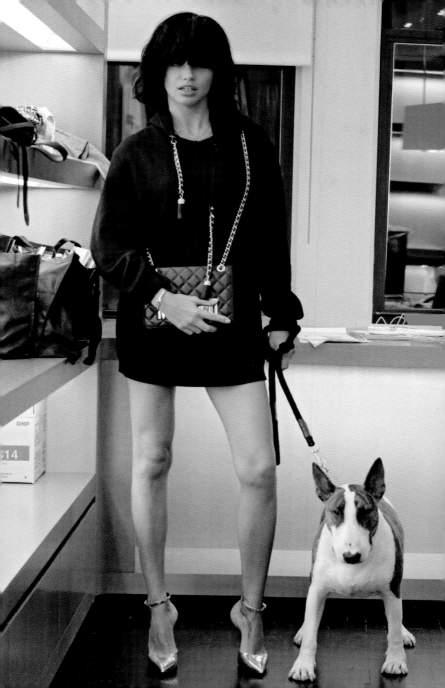

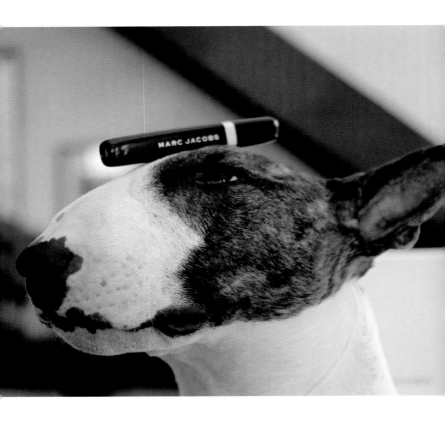

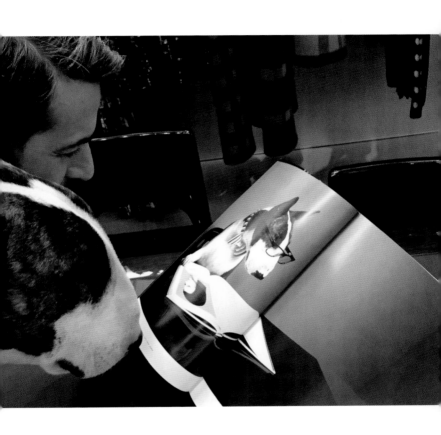

ME AND DAD CHECKING OUT
MY FIRST PRINT CAMPAIGN FOR BOOKMARC.
HEY, I EARNED IT!

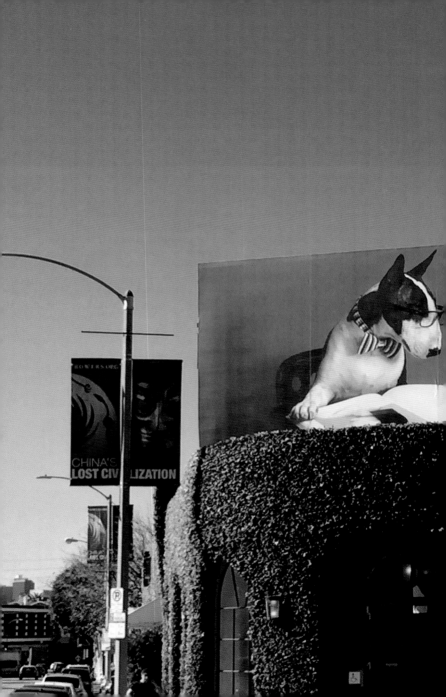

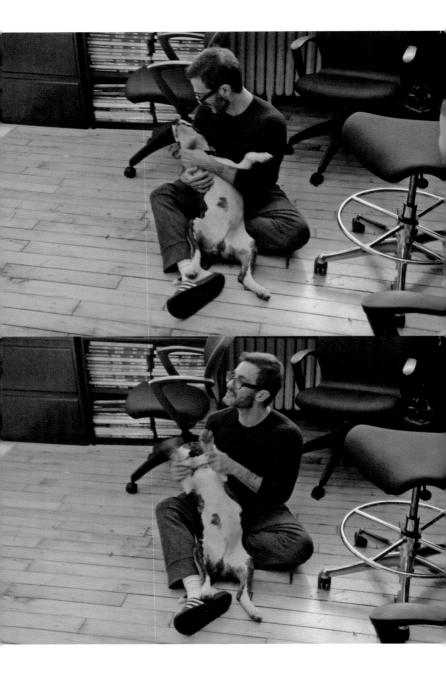

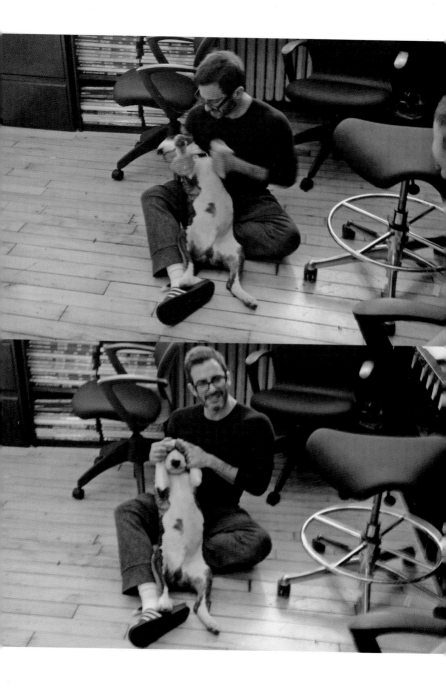

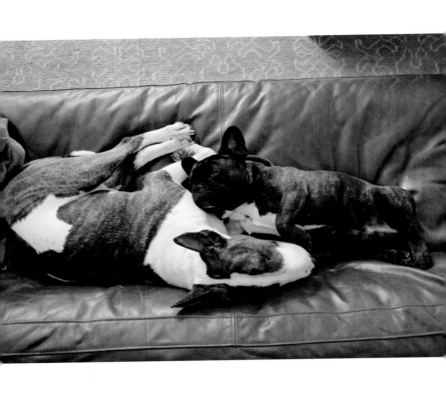

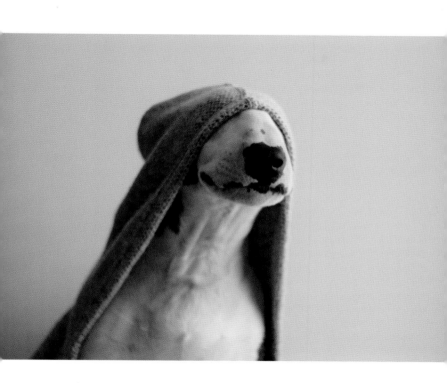

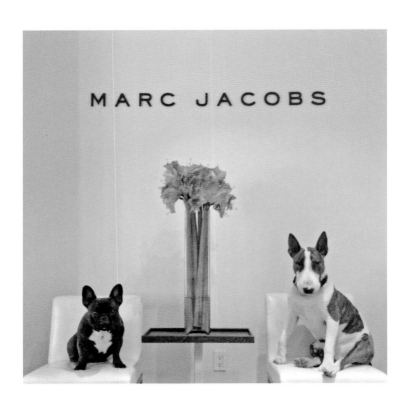

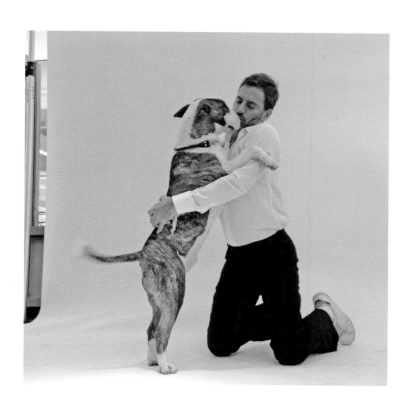

A BREAK TO KISS MY DAD
DURING FASHION WEEK CASTINGS.
MY FAVORITE TIME OF YEAR!

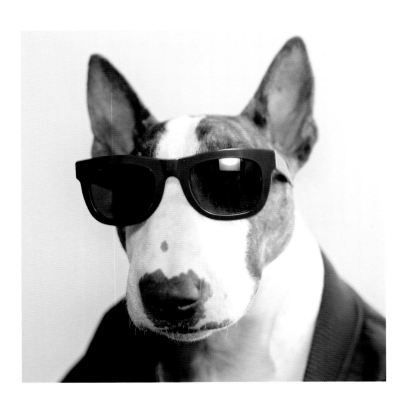

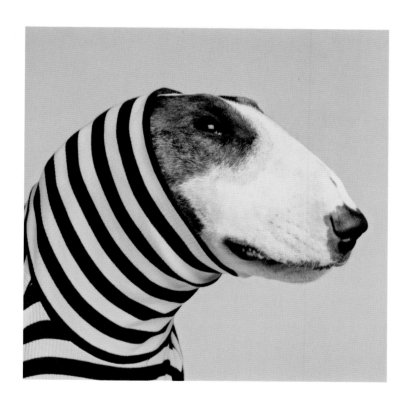

GEORGIA MAY JAGGER UP FROM HER NAP
AND LOOKING STUNNING, AS ALWAYS.

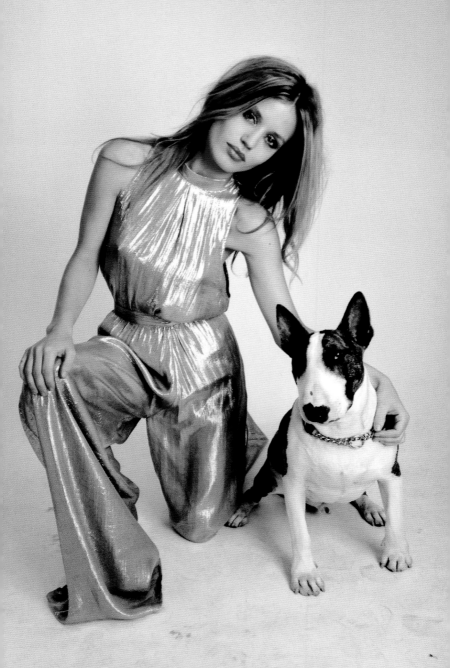

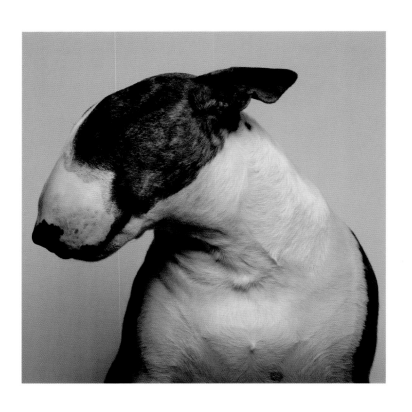

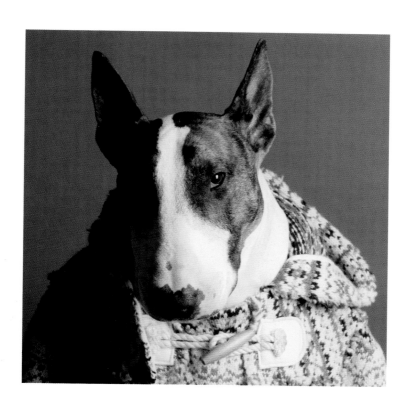

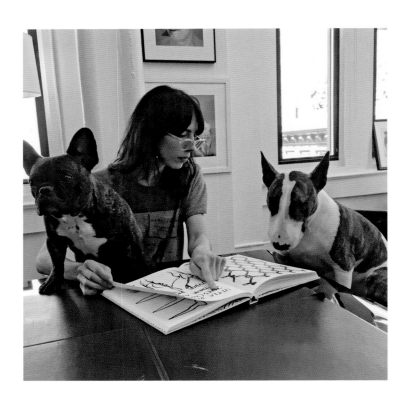

CHARLIE'S GIRLFRIEND, JAMIE BOCHERT,

TEACHING US HOW TO READ.

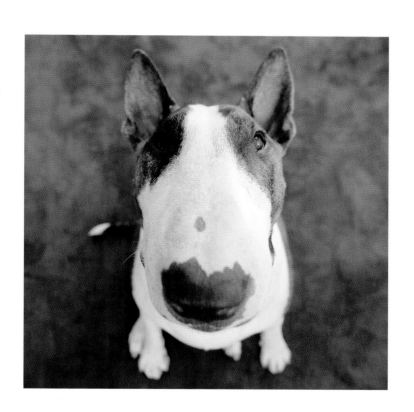

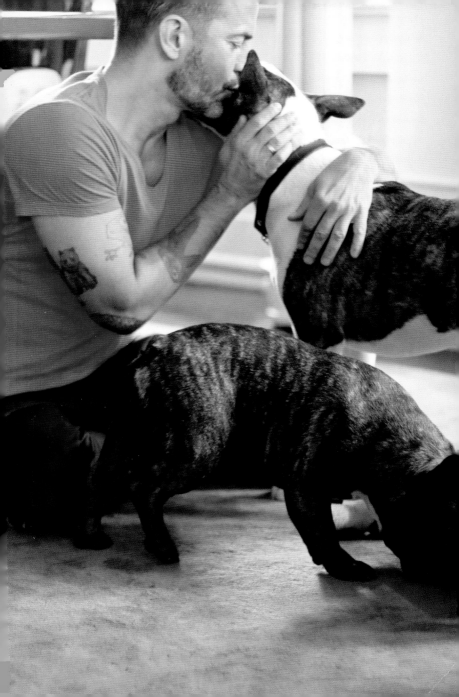

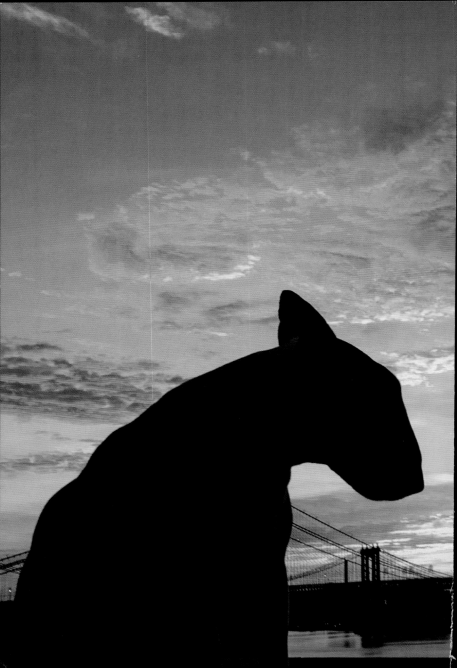

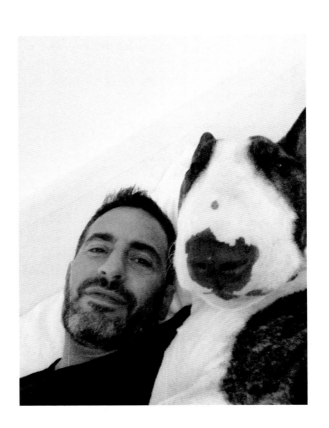

FIRST PUBLISHED IN THE UNITED STATES OF AMERICA IN 2016 BY
RIZZOLI INTERNATIONAL PUBLICATIONS, INC.
300 PARK AVENUE SOUTH NEW YORK NY 10010
WWW.RIZZOLIUSA.COM

© 2016 BY NICOLAS NEWBOLD
FOREWORD © 2016 BY MARC JACOBS
PHOTOGRAPH ON PAGE 211 BY CALVIN WILSON
PHOTOGRAPH ON PAGE 235 BY RYAN HASTINGS
DESIGN BY AMINA RAB PETER MILES STUDIO

ISBN: 978-0-7893-3261-5
LIBRARY OF CONGRESS CATALOG CONTROL NUMBER: 2016940677

2016 2017 2018 2019 / 10 9 8 7 6 5 4 3 2 1

PRINTED IN CHINA

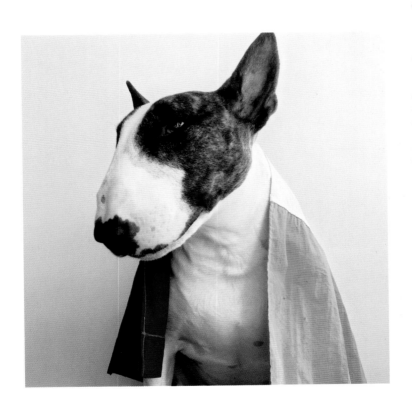